THATCHAM
THEN & NOW
IN COLOUR

DR NICK YOUNG

The History Press

The book is dedicated to my parents, Paul and Margaret Young, and to my Nan, Pam Smith, who have supported me for as long as I can remember; also to the memory of my Grandad, Brian Smith, and to my local history mentor, Peter Allen.

First published in 2012

The History Press
The Mill, Brimscombe Port
Stroud, Gloucestershire, GL5 2QG
www.thehistorypress.co.uk

British Library Cataloguing in Publication Data.
A catalogue record for this book is available from the British Library.

ISBN 978 0 7524 6276 9

Typesetting and origination by The History Press
Manufacturing managed by Jellyfish Print Solutions Ltd
Printed in India.

CONTENTS

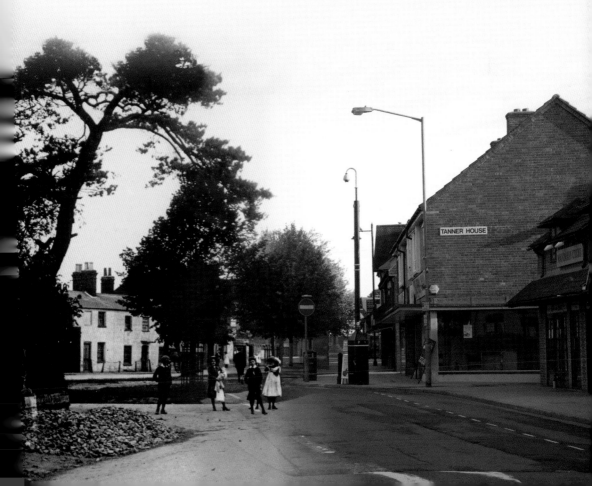

ACKNOWLEDGEMENTS

This publication would not have been possible without the support of a great many people and organisations. Some have loaned me their photographs or given me permission to reproduce them, others have shared their knowledge and some provided me access to various locations to take photographs. The generosity I have received is greatly appreciated. The people and organisations are, and I apologise if I have inadvertently missed anyone out, Bill Butler, Dr Neil Clifton, Mike Elliot, Richard Foster, Mary Lay, Mavis Pinnock, Graeme Stewart, Stuart Wise, Chris Watts (St Mary's Church, Thatcham), J. Salmon Ltd, the Francis Frith Collection, Judges of Hastings, Francis Baily School, Hallmark Cards, Museum of English Rural Life (University of Reading), *Newbury Weekly News*, Malcolm Langford, Alf Wheeler, Tony Higgott, Bob Dewey, Thatcham Historical Society, David Wootton, Barbara Smith, Kath Nailor, John Eggleton.

Every effort has been made to trace copyright owners of material used within this publication. I sincerely apologise if there is any material that has been used without acknowledgement. All of the modern photographs, unless stated otherwise, have been taken in 2011 by myself. All of the old photographs, unless stated, have been taken either from my own collection or from the collection of the late Peter Allen.

You can find out more about Thatcham's rich past by contacting the author and/or Thatcham Historical Society (www.thatchamhistoricalsociety.org.uk).

INTRODUCTION

Thatcham has a rich past, with evidence of human presence stretching back to the Palaeolithic era (Stone Age). Other evidence shows animals and plants thriving here long before that. Stone Age Thatcham would have been unrecognisable to us; it is the Saxons to whom we owe the existence of the town we know today. It is believed they settled here, building a settlement around a church, supposedly near where St Mary's is today. It is not known how big this settlement was, although an idea can be gleaned from the Domesday records, which show approximately 250 people living and working in Thatcham.

The medieval period brought prosperity and ultimately saw Newbury take over as a place of trade and industry. Despite this, Thatcham did continue to grow and succeed. By 1901, there were around 2,900 people there. However, the events of the twentieth century saw a dramatic change – partly due to the baby boom and Thatcham's location as a commuter town – and by 1971 the population had reached around 10,000. This allowed Thatcham to become, officially at least, a town rather than a village. Many today still affectionately refer to the town centre as 'The Village'. Today, the population is estimated to be around 24,000.

Whilst the population increase shows that Thatcham is thriving, it does beg the question of what has happened to Thatcham itself. As well as population increases, there is an obvious need for more housing; with more housing and population comes the requirement for additional industry and commerce, although it may be those driving people here to start with. The bottom line is that Thatcham has changed and continues to change.

Within the last thirty years the town centre has been transformed. The High Street, although altered, is still recognisable; the Broadway, however, has changed substantially, beyond recognition in some cases. Thatcham encompasses a wide area and, unfortunately, space in this publication is limited; thus there are many views that simply could not be included. But it is my aim to show a glimpse of some of the developments that have been made, as a record of the town.

Dr Nick Young, 2012

THE TURNPIKE

THE THATCHAM TURNPIKE, at the western edge of Thatcham, *c.* 1910. The turnpike was part of the Speenhamland to Reading Trust and was located across the road from the present Wyevale Garden Centre. This consisted of a toll house and a gate, which has been referred to as Thatcham Gate. It first became a toll road in around 1720. The eighteenth and nineteenth centuries saw the rise of Turnpike Trusts, peaking in the 1830s. These trusts were set up to allow collection of a toll for use of the road. In turn, the tolls collected were used by the Trusts to maintain the roads. Some of the materials

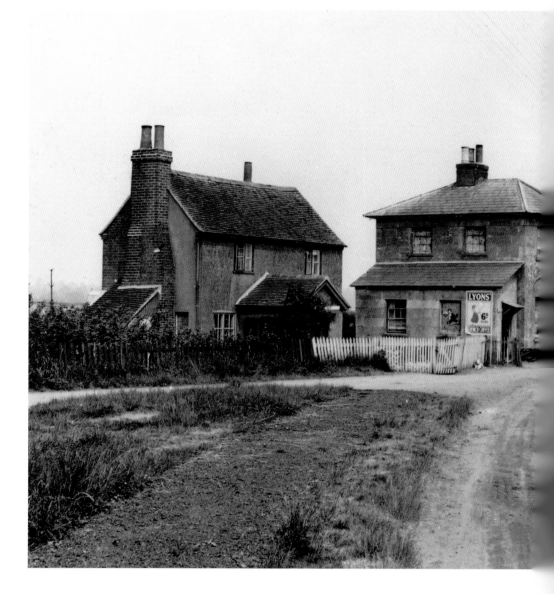

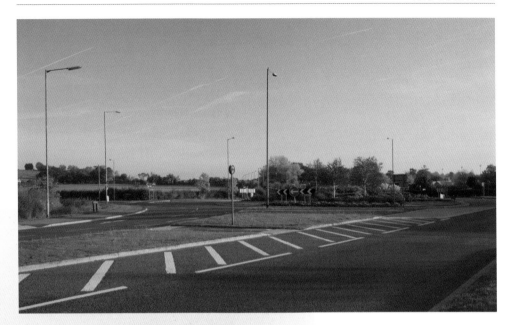

used to repair the roads were known to have come from local gravel-extraction sites. *(Postcard supplied by Graeme Stewart)*

THE TURNPIKE REMAINED in operation until around 1875. The toll gate itself was taken down in 1878, although the buildings themselves remained standing until around 1965, when they were demolished. The cottage on the left of the old picture was, prior to the First World War, a sweet shop that was very popular with local children. Not too far along from the toll house were the French Gardens. French Gardens, also known as Thatcham Fruit and Flower Farm, was a school where ladies were taught horticulture in the early 1900s. Eventually, the whole area was developed; a garden centre opened in 1989 and, later, a new traffic system was put in place.

TWELVE APOSTLES

THE BATH ROAD, just west of Beverley Close, *c.* 1910. There are six identical buildings here, each split into two attached houses, known locally as the 'Twelve Apostles'. They were built in 1900 for managers and foremen working at Colthrop Paper Mill and were eventually sold off into private ownership. There are numerous areas around Thatcham that were built specifically for Colthrop; for example, there is another set of houses at the eastern end of the London Road, opposite the cemetery, which were built in 1913. Many of the buildings, including the Twelve

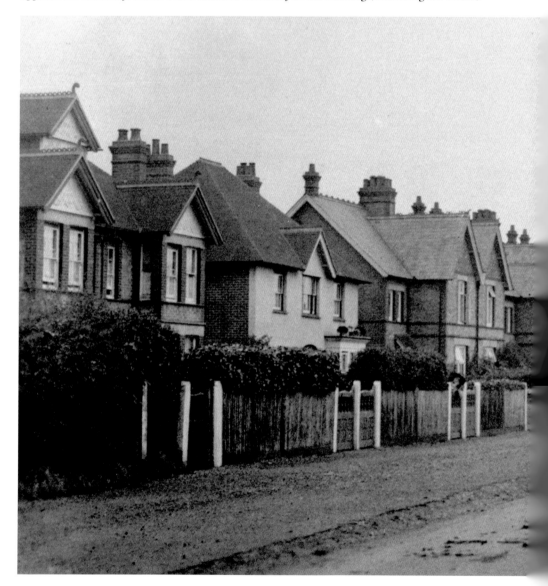

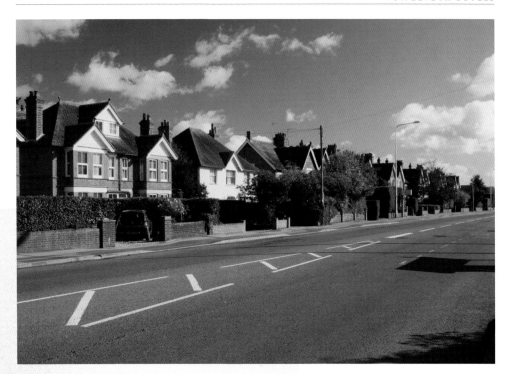

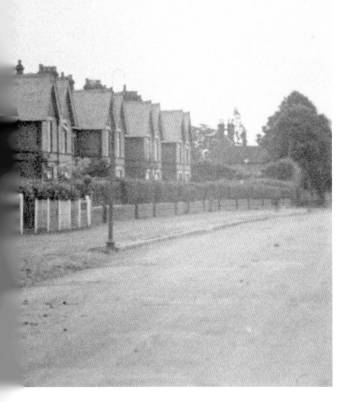

Apostles, have two different coloured bricks, typically red and blue or red and white, arranged into some sort of pattern. The Bath Road (the A4), although the main road, was not made popular until the 1700s, when the city of Bath became a popular destination. To help reduce dust on the road, Beau Nash of Bath had water pumps installed at intervals along the road from London to Bath in 1754. The road surface looks in rather poor condition in this scene.

SHOWN HERE IN September 2011 (above), the Bath Road has clearly undergone modernisation – namely the streetlights and road markings. The houses remain under private ownership today and look largely unaltered, at least externally; many still have the outbuildings as well.

BEVERLEY HOUSE

BEVERLEY HOUSE WAS originally
known as Cooper's Cottage, where, in
1827, Thomas Cooper set up as a coach
operator. Thatcham had two other
coaching inns, including the King's Head
and the White Hart, each providing four
coaches a day. There were three walled
gardens surrounding the cottage and
another on the opposite side of the road,
all providing fresh produce for the inn.
The coach business was not successful
and Thomas went bankrupt in 1832,
although he retained the cottage and
coaches still stopped for refreshment.
However, the coaches failed to compete
well with the railways and Thomas
eventually moved elsewhere.

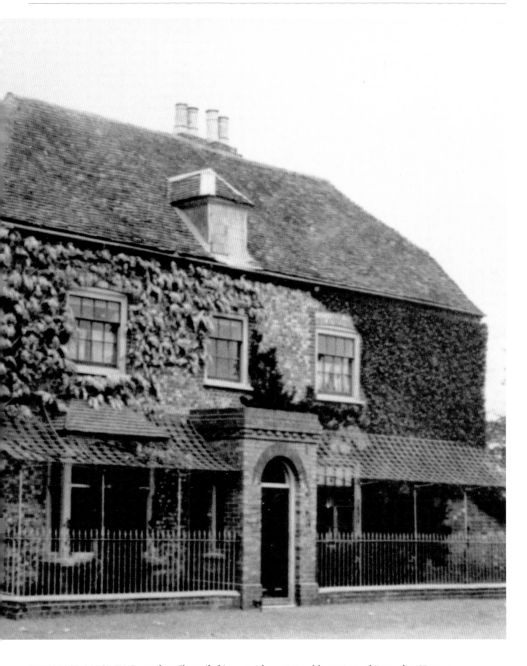

THE ENTRANCE TO Beverley Close (left), near the original location of Beverley House. In 1851, John Mecey, originally from Winchester, bought the cottage. Mecey and several generations of his family were well-known solicitors, with John becoming the first clerk to the Parish Council. Sometime during 1901, the Coulson family moved in, having previously lived in Beverley, Yorkshire. By 1929, it was renamed Beverley House. The house stood until around 1958/9, when it was demolished to make way for Beverley Close and Coopers Crescent.

MEMORIAL HALL

MEMORIAL PLAYING FIELDS with the then newly erected clock tower (below), *c*. 1960. The Memorial Playing Fields, which covered a larger area than it does today, came into use in 1947 and was maintained by a small force of volunteers until 1972, when the Parish Council took over. In 1951, the first Memorial Hall was built to commemorate those who fell in the Second World War. Shortly after, in 1953, the clock tower was built in commemoration of

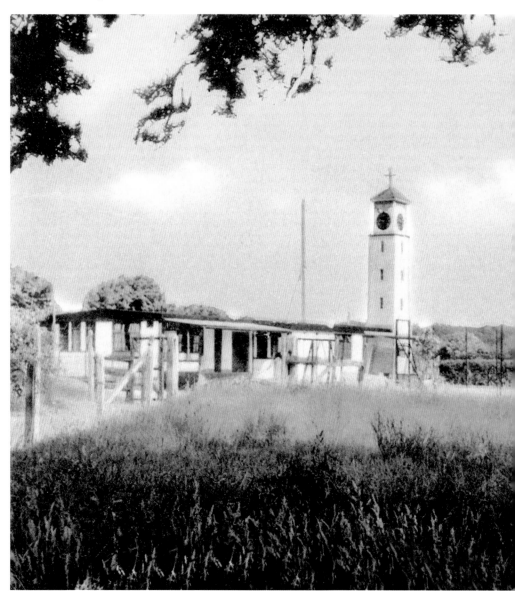

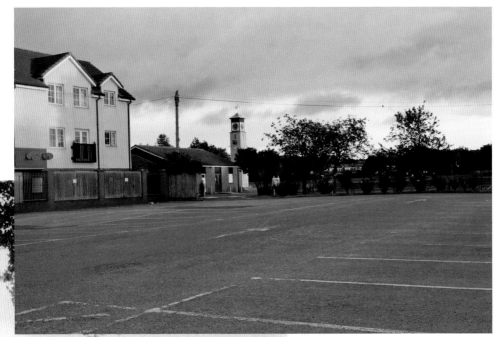

the coronation of Queen Elizabeth II. The tower cost £400, which was financed by various companies at Colthrop. A clock was also supplied by Mr Arthur Brown, son of Mr C.G. Brown. *(Postcard supplied by Graeme Stewart and reproduced by permission of the Francis Frith Collection)*

TODAY, MUCH OF the green space has been turned into parking spaces. In 1954, for the first time in three centuries, a Roman Catholic mass was celebrated on the premises of the hall. Around 1967, Thatcham Library, which was situated in the Parish Hall since 1924, was moved here and remained at this location until 1979, when the present library was built. A Bowling Club was also opened in 1979 on the Memorial Playing Fields. In 1982, a new Memorial Hall was erected to replace the earlier hall.

GREEN LANE TERRACES

GREEN LANE TERRACES, *c.* 1910. This terrace of houses were situated at the southern end of the road and dated to about 1870. They were demolished in about 1961 and today Crown Acre Close occupies the site. Prior to 1894, the land was owned by Albert Carter, but was sold to George Wallis, whose family farmed at nearby Thatcham Farm, in 1898. Sometime around 1900,

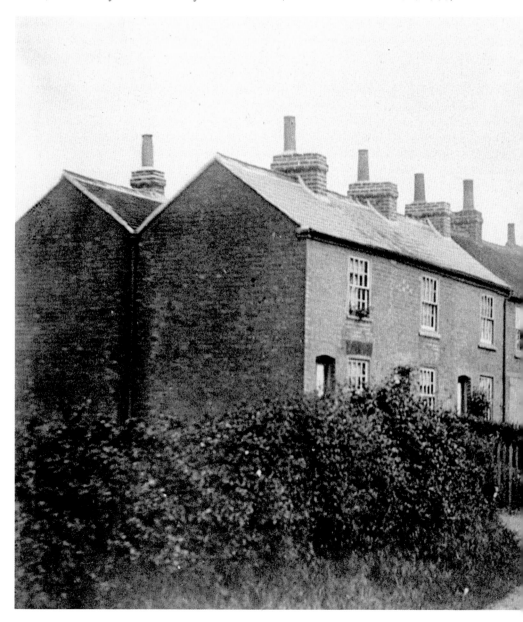

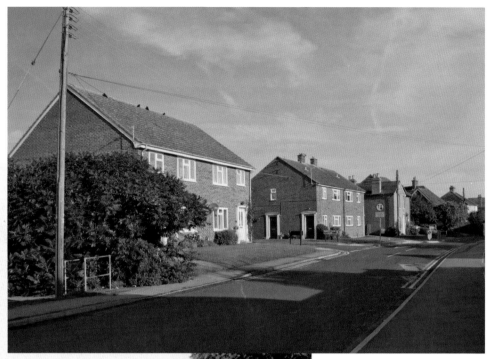

a terrace was built just off to the west of the terraces shown in the old photograph. They still stand today and were named Hollington Place, the name originating from Hollington Farm at East Woodhay, where George's wife, Sarah, was born in 1848.

A NEW ROW of houses has been erected as well as the development of Crown Acre Close. A 'green lane' is typically an old or ancient un-surfaced road or track way. They would have linked farms or other rural areas to a main road or settlement. There are two other green lanes in Thatcham; Henwick Lane and Pound Lane.

THE POPLARS

THE POPLARS ON the Bath Road, just west of the High Street, *c.* 1914. The Poplars, originally known as Walnut House – although some referred to it as The Walnuts – was built in the late eighteenth century. Today, it is officially known as Bradley Moore House, although many refer to it by its business name, The Cedars. The Poplars was owned and lived in by various families, including the Baily family; John Brown, who had a wood-turning business in the Broadway; Richard Stroud

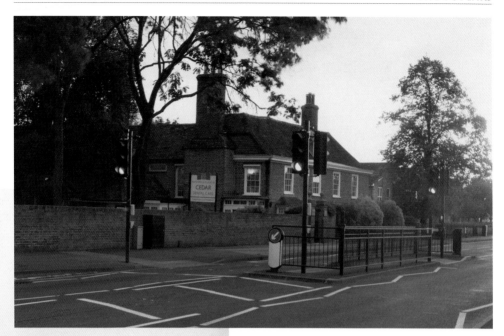

and James Lay. Since 1914, the Poplars has been connected with health services. The first medical use was made by Dr T. Martin, who was responsible for the health of villagers. A string of other doctors followed, including Dr P. Ransom, Dr J. Beagley and Dr D. Bradley-Moore. Dr D. Bradley-Moore worked here for thirty-two years until 1977. By this time, the medical needs of Thatcham had grown and a new health centre was built in the garden of the Poplars; it was completed in September 1978. The new surgery was staffed by seven doctors, seven nurses, four health visitors and twenty additional personnel.

IN 1999, THREE years after Dr D. Bradley-Moore passed away, the Poplars became home to a dental surgery, Cedar Dental Care, which is still in practice to this day. Little externally has been altered on the house, however, the garden is now a shadow of what it used to be. Notice that the house still has iron railings. The road has been altered to include traffic lights, using a system designed to only stop one flow of traffic at a time, although its effectiveness is still often debated amongst locals.

HIGH STREET

THE HIGH STREET, looking east, *c*. 1914. The buildings on the left of this scene were demolished in 1934 for road widening. Further developments and changes were undergone in 1962 with the building of the A4, or relief road, and a seating area. The building on the left, with the women outside, was Gush's Milk Transporting Services, which collected cradles from the farms and delivered them to the railway station. Next door, the building with the overhang was the premises of Norris the fishmonger and fruiterer. Many locals have memories of various other shops at this end of the High Street. One recalled by many was Mrs Elizabeth Randall's sweet and florist shop,

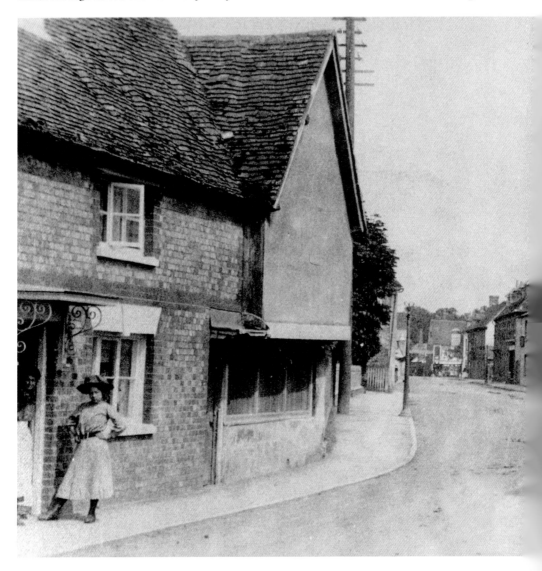

where for half-a-penny you could purchase a cornet with home-made ice cream. Mrs Randall was officially listed in the 1934 trade directory as a tobacconist, although such shops often, as was the case here, sold a variety of products, not just tobacco. Other shops along this stretch of the High Street included refreshment rooms operated by Mrs Maud Adams; several locals have recollections of her selling groceries and toys also. At No. 32 was the ironmonger's shop originally kept by Mr F. Reynolds and, later, by Mr Charles Pazzard. The latter also traded furniture, china and glass.

TODAY, THE HIGH Street retains its historic character, as few of the buildings have been demolished. Generally, this part of the town centre flourished. It is only in the last few decades that trade has seen a downturn, with many shops struggling to survive, perhaps due in part to the economic situation or perhaps because of competition from the larger stores in the Broadway.

THE UNITED REFORMED CHURCH AND BRITISH SCHOOL

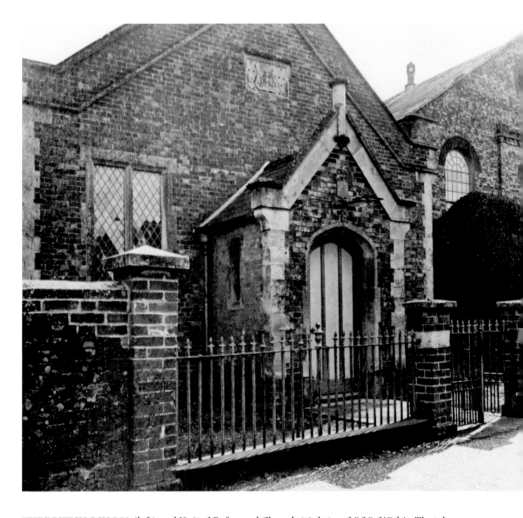

THE BRITISH SCHOOL (left) and United Reformed Church (right), *c.* 1930. Within Thatcham there have been non-conformists since the sixteenth century, including Nicholas Fuller, a barrister who purchased the Chamberhouse estate, and Thomas Voysey, a vicar who was removed from service at St Mary's in 1662 after being accused of plotting against King Charles II. Sampson Higgs started to hold meetings in 1800 at his home, and in 1803 a group was held at a cottage owned by Mrs Hannah Baily. It took time for people to come to accept these alternate views and beliefs.

John Barfield, who constructed the priory and then lived in it, gave both land and money towards the building of a chapel for non-conformists. Some of the building materials used came from the recently demolished Manor House in Dunstan Park. The chapel was completed and opened as an Independent Church in 1804, although it was not welcomed by many. Some even burnt an effigy of John Barfield, whilst others threw mud and stones at those attending the church. Although a church was built, it did not have a permanent minister until around 1813, when William Ash was appointed. By 1844, the idea for a non-conformist (British) school was put forward. Mainly due to the efforts of Sarah Barfield, wife of John, the British School opened in 1847 and in 1874 became a public school. Sarah managed the school from 1847 to 1852. At this time there were 100 pupils on the register, and once William Brown had been put in place as the new teacher, the numbers soon increased to over 140. The last teacher to be put in charge was Horatio Skillman, who, in 1913, transferred his staff and pupils to the newly built Council School (Francis Baily). Although the school moved, the building is still referred to as the British School. Indeed it has been used as such; in the Second World War it was used as a classroom and between 1957 and 1964 it was used by Kennet School. Other activities also continue to take place there, including badminton, coffee mornings and pantomimes. The church later became a Congregational Church, and in 1972 became the United Reformed Church.

THE BUILDINGS LOOK much the same today, apart from the removal of the wall and railings – probably removed during the Second World War, the new glass entrance between the church and the British School, and a new bike shelter in front of the church. Church Lane, also known in the nineteenth century as Front Lane, gave access to the Church of St Mary.

THE POST OFFICE

THATCHAM POST OFFICE, Drug and Photographic Store, *c.* 1940. This property, No. 35, was once the offices and home of the Mecey family, who also resided in Beverley House in the 1850s. John Mecey worked from here as a solicitor, with another two generations following in his footsteps. The front garden was originally secluded with iron railings and hedges. The back garden extended 100 yards up into Park Lane; remember that the A4 did not run along the back of the High Street until 1962.

The house was eventually sold, although one part was retained as a solicitor's office. In 1934, Thatcham's post office was located here, on the left of the store. The post office also occupied various buildings along

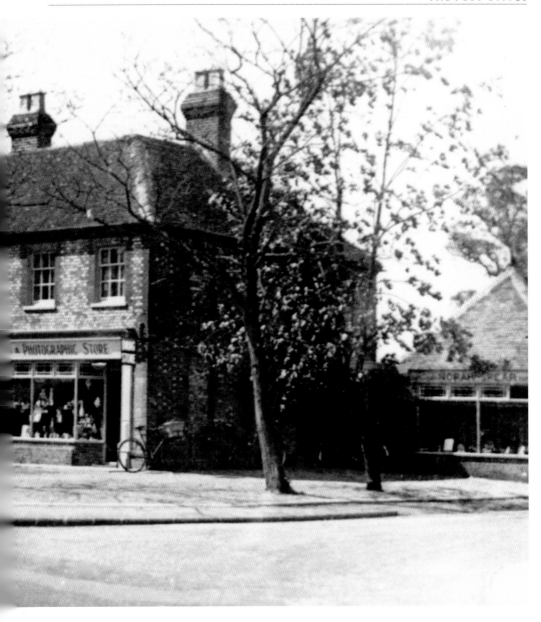

the High Street. The last official sub-postmaster was Mr Basil Gilmour, who also operated as a tobacconist. On the right was No. 1 Park Lane, which was Norah Spear's Hairdressers.

IN THE 1970s the front of the building was extended for the Thatcham Motor Shop. What is seen today has largely remained unchanged since the 1970s. There is still a hairdresser's occupying the building on the right-hand side; the main house, however, is now an Indian restaurant called Spice, and a carpet company.

PARK LANE

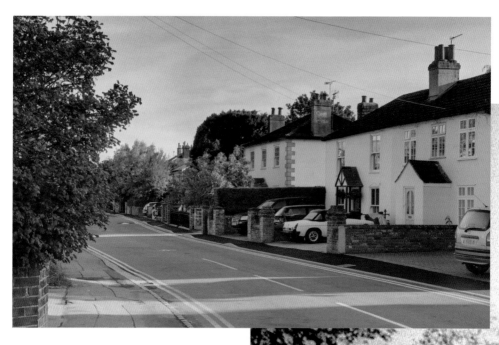

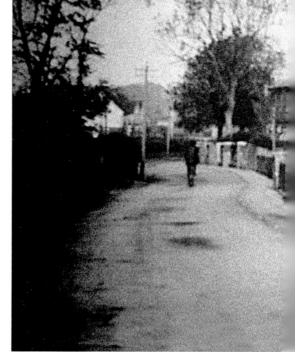

PARK LANE LOOKING north, *c.* 1920 (right). Before the 1880s, Park Lane was known as Back Lane (and Church Lane was Front Lane). A house known as Wetherdene can be seen in the distance (next to the tree on the right of the cyclist); this was the property of Mr Arthur Brown whose daughter, in 1923, opened a preparatory school in Park Lane. Until the relief road was built in 1962, Park Lane continued all the way into the High Street. The building of the relief road, which is today the A4 section that stretches from the top of the Broadway to the western end of the High Street, saw many properties and gardens demolished and Park Lane shortened. Halfway up Park Lane is a group of houses that were known as Turncroft Cottages and towards the northern end of Park Lane were Whitelands Cottages and Whitelands Farm. There was also a ditch that ran along the west side of the road.

THE DITCH HAS long since been filled in, perhaps adding to the floods of 2007. The farm is no more; however, the cottages do still exist. At the top of the northern end, where Park Lane meets Heath Lane, there was a small pond known as Grey's Pond. This, along with all of the other ponds in Thatcham, has long since disappeared. In 1844, William Mount gave land in Park Lane for a school to be built on, which was the National School. The school opened in 1846, largely due to the efforts of Reverend Vincent Clementi. Development in Park Lane continued and, in 1921, several new houses were erected. Development of new houses and demolition of older houses continues to this day.

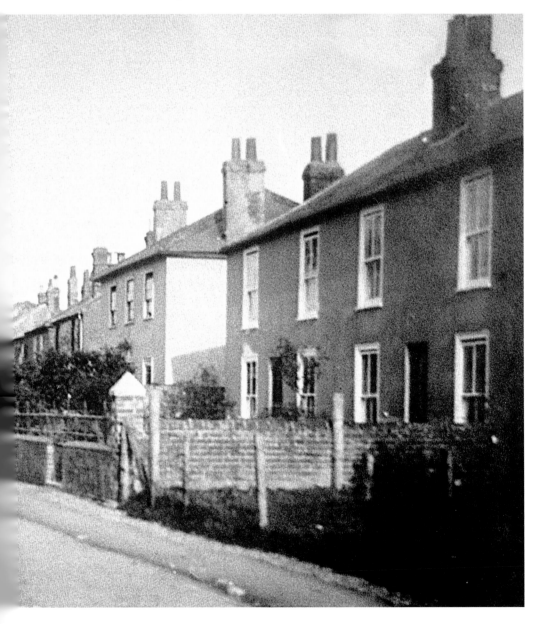

HIGH STREET, LOOKING TOWARDS THE BROADWAY

THIS VIEW FROM around 1960 shows the bicycles and cars that were typical of the period. This was a time when cars were still a luxury for many and local trips would have been done on foot or by bicycle. Mr Thomas Oakeley kept a chemist, or drug store as it would have been referred to, at the Broadway end of the High Street. Mr Bernard Brooks kept a corn merchant's shop at No. 3 and next door, at numbers 5–7, was Lay's the grocers, staffed by Bill and Bert Lay, along with Miss Jenny Pike. There was also an outfitter's shop, owned by Mr Alfred Gibbs. There was, at one time, a series of alleyways behind the High Street, two of which were called Soapsuds Alley and Clinker Alley. Most of the alleys were demolished around 1911. *(Postcard supplied by Graeme Stewart and reproduced by permission of The Francis Frith Collection)*

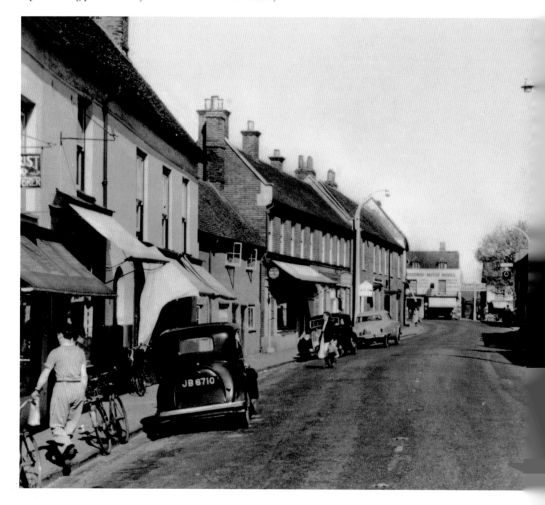

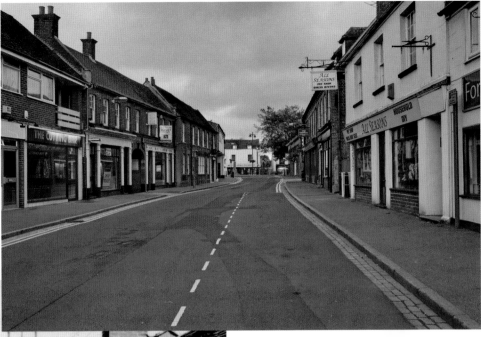

HISTORICAL DOCUMENTS INDICATE the High Street has been called various names; it was once referred to as Crown Street, referring to The Crown Inn, which stood along this road just on the right-foreground of the photographs. The pub was owned by George Mayhew and survived until 1954, after which it became the Crown Boot shop, run by Frank Ashman. Today this is occupied by All Seasons, a general store selling pet food, DIY tools and general household items. Archaeological excavations have provided evidence of fourteenth-century burgage plots extending along the High Street, as well as other artefacts including fifteenth-century pottery. The post office moved to No. 7 High Street, from Chapel Street in 1854. In 1912, the post office had the first public telephone in Thatcham installed. It changed location several times, although it remained in the High Street until 1974, when it moved to the Broadway, returning to the High Street in 1983. The post office then moved to its present location in the Broadway in 1998.

THE MARKET CROSS
AND HIGH STREET

THE JUNCTION BETWEEN High Street and the Broadway, *c.* 1935. Originally, in the fourteenth century, it was called West Street. In the late eighteenth century it was known as Chip or Cheap Street, referring to the trade and market that took place along and/or near here. A record from 1851 shows it was also called Crown Street, referring to the Crown Inn, which once stood along this road. Although the name High Street was referred to in the late nineteenth century, it was not widely adopted until around 1900. It was made official when road names were formally adopted

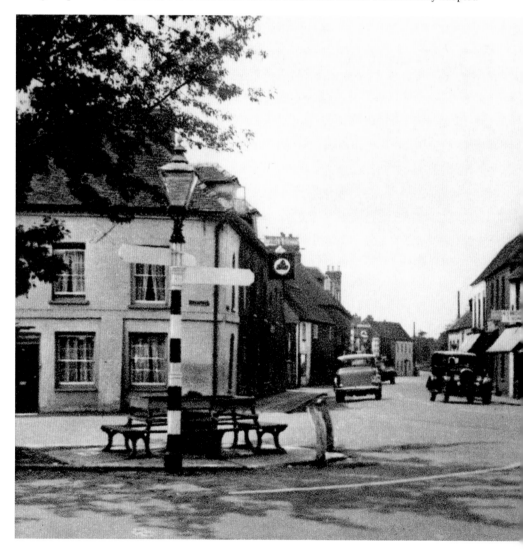

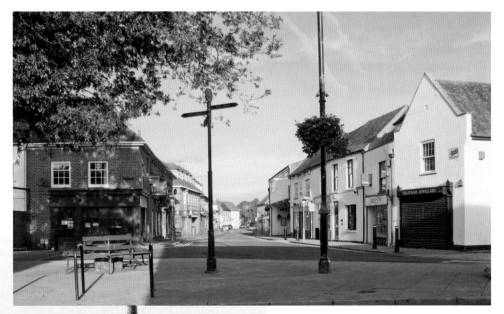

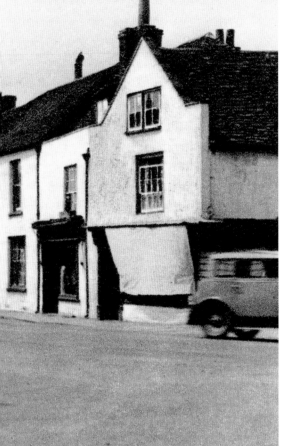

in 1928. The seat to the left of the old photograph surrounds the butter cross, which was a market cross to show that locally produced milk, butter and eggs were all sold here. The butter cross was, it is believed, erected in the thirteenth century, although the market itself is much older. It is not known exactly when the cross disappeared, but it is believed to have been before the nineteenth century. *(Reproduced with permission of Hallmark Cards, supplied by Graeme Stewart)*

THE SEAT WAS donated by Samuel Barfield of the priory in 1892. Sadly, it has been vandalised several times, although each time it is repaired. In 1984, replacement seats were made by pupils and staff from Kennet School. Today, the building on the right is Thatcham Jewellers, once home to C.G. Brown, who established his clock and watch repair shop here in 1891, before moving to the Broadway in 1911. Various other shops have been located here, including Swift Cleaners in more recent times.

WYATT'S FAMILY BUTCHER

WYATT'S FAMILY BUTCHER, game dealer and poulterer, at the northern end of the Broadway, *c*. 1911. Records show this shop as being in Chapel Street, Broad Street (Broadway). Chapel Street would have ended where Wyatt's shop was, so the reference to either street was more of a personal preference, although by the 1920s most references are firmly with Broadway. Robert Wyatt, originally from Speen, moved to Ashmore Green to live with relatives after the death of his parents.

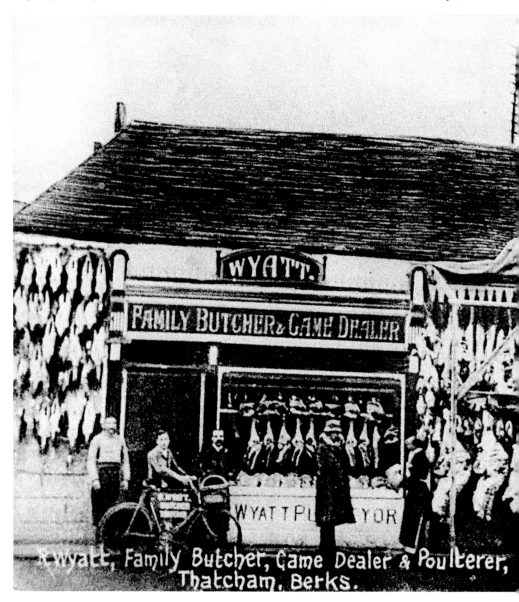

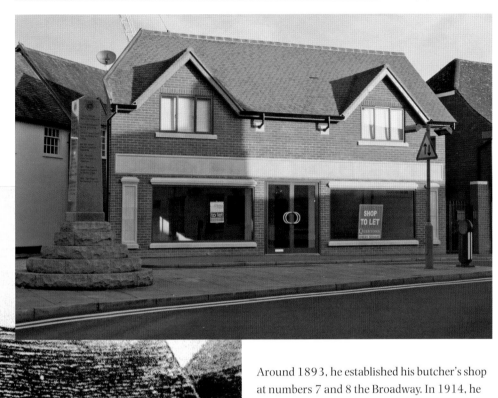

Around 1893, he established his butcher's shop at numbers 7 and 8 the Broadway. In 1914, he took over the running of Harts Hill Farm, which included 300 acres of land and fifty Guernsey cows. The herd supplied most of the milk for the village. Robert died in 1931 and, for a period, Lionel Baker kept the butcher's shop running.

THE BUSINESS CONTINUED to run from the same location until 2006, when, due to higher running costs, the owners were forced to move out of the town. In 2009, the building was subsequently demolished and rebuilt with residential and commercial properties. Between the demolition and rebuilding, archaeological excavations were undertaken. Various finds were made including a wall and two pieces of possible worked flint. A tiled floor was found below the shop, dating to the nineteenth century, as well as a medieval wall foundation and a late seventeenth-century clay pipe. The evidence suggests that the site has been occupied for centuries.

THE WAR
MEMORIAL &
THE BROADWAY

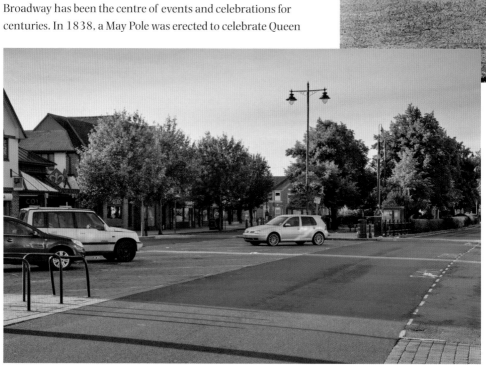

THE BROADWAY HAS traditionally been the heart of Thatcham and has seen many changes, most of which has only taken place in the last three decades. Compared to the High Street, the Broadway is barely recognisable. The Broadway was known as South Street in the fifteenth century, but Broad Street was the name used from the late sixteenth century until the early twentieth century. Indeed, records from the time show Broad Street and Broadway used interchangeably. Officially it was named Broad Street in 1928, although by the Second World War it was referred to as the Broadway. The green dates back to medieval times, but may be older. There was a pond called the Bell Pond on or near the modern green in 1698 and earlier. The pond survived into the nineteenth century; however, it was gone by the end of the century. The Broadway has been the centre of events and celebrations for centuries. In 1838, a May Pole was erected to celebrate Queen

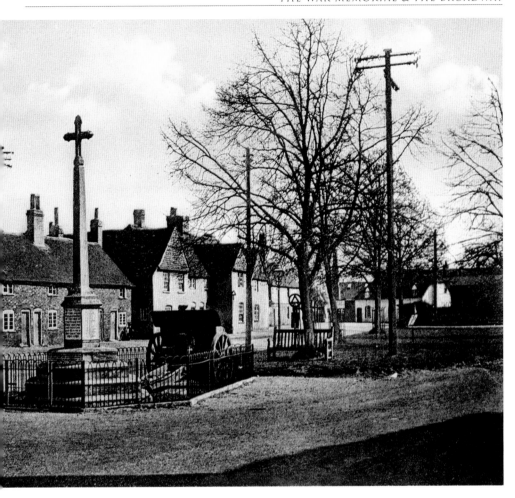

Victoria's Coronation. The pole remained standing until 1864, when it was taken down on safety grounds. There was also, to celebrate the coronation, the first known 'Anvil Firing' or 'Anvil Salute'. This is where anvils are loaded with gunpowder and ignited. This seems to have been a custom for a long time, and a popular one. Anvils were fired on several occasions, including in 1897 when they were fired at 4 a.m. by the village blacksmiths, the Wheelers, to celebrate the Diamond Jubilee of Queen Victoria. The last firing was at the Thatcham Festival in 1970.

MANY OF THE buildings shown in the old photograph were over 100 years old; few have survived to the modern day though. Today, the space is occupied by a small car park. After the First World War, a memorial was erected, designed by Sir Charles Nicholson of London. A German Howitzer, which was captured by Alexander Turner's Battalion, is also displayed at the top of the green. They were both formerly dedicated on 11 November 1920. The memorial was unveiled by General E. Dickson of the Royal Berkshire Regiment and the gun was unveiled by Major and Mrs Turner. The gun was removed for scrap metal in 1940 and the memorial moved in 1966 to the bottom end of the memorial playing fields, where it remains today.

THE FIRST
NATIONAL SCHOOL

AT THE TURN of the nineteenth century, the only school in Thatcham was the Bluecoat School, which was for boys. In 1828, the National School was opened, largely due to the work of the vicar, Reverend Joseph Lothian. The school was built on the site of some of Hunt's charity houses and measured just 40ft by 18ft. The building would have occupied, roughly, the part of the roadway

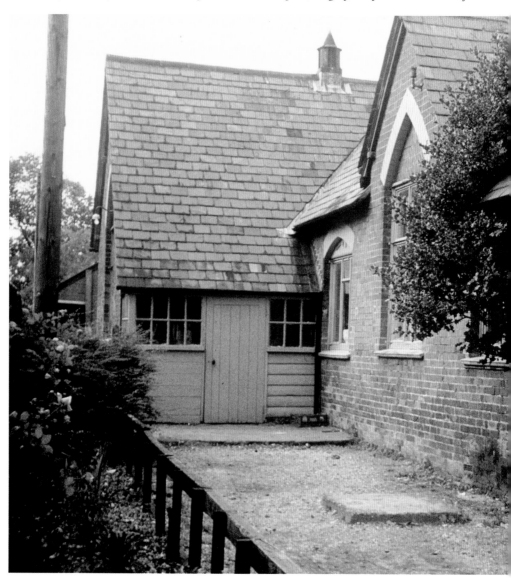

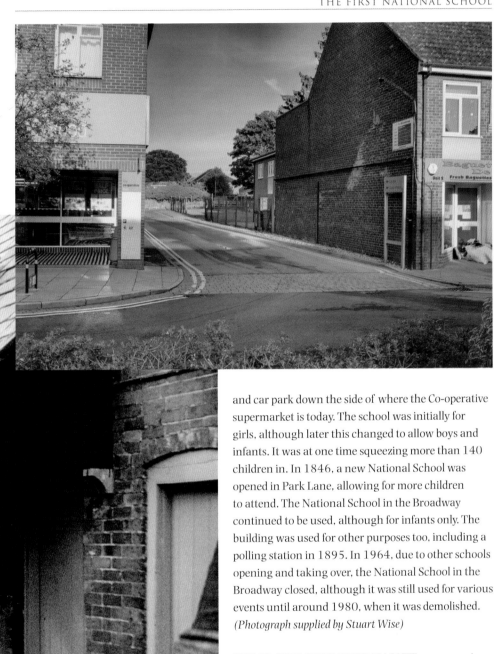

and car park down the side of where the Co-operative supermarket is today. The school was initially for girls, although later this changed to allow boys and infants. It was at one time squeezing more than 140 children in. In 1846, a new National School was opened in Park Lane, allowing for more children to attend. The National School in the Broadway continued to be used, although for infants only. The building was used for other purposes too, including a polling station in 1895. In 1964, due to other schools opening and taking over, the National School in the Broadway closed, although it was still used for various events until around 1980, when it was demolished. *(Photograph supplied by Stuart Wise)*

THE CO-OPERATIVE SUPERMARKET now occupies this site. It was built in the 1960s on the former premises of Frederick Spanswick, who had established a motor coach business here in the early 1900s. The co-operative store was extended when the school was demolished, and still stands there today, leaving no evidence of the former National School.

THE BROADWAY

A RURAL-LOOKING Broadway as seen from the church tower in about 1900 (below). A view from the church tower reveals, in a single glance, what and how much has changed. In the distance, open fields can be seen. Today, these are occupied by Park Avenue and Dunstan Park. Sadly, this is the case with many of the green spaces that existed 100 years ago. It is said that many of the

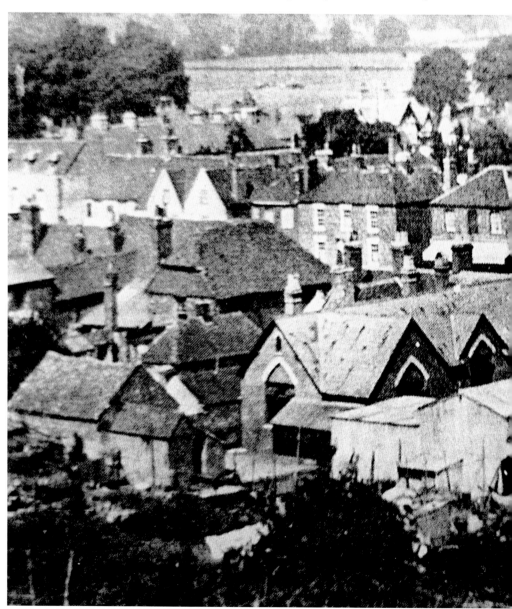

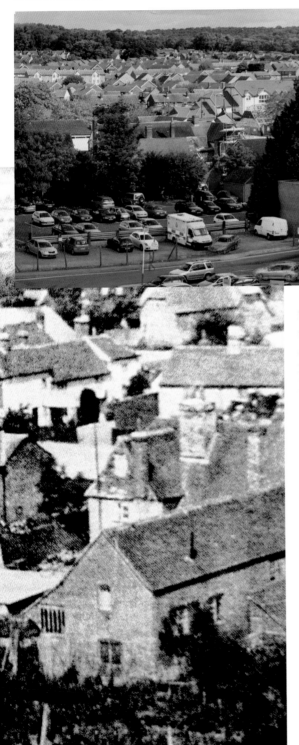

buildings in the Broadway at the time this old photograph was taken were already 100 years old. The size of the National School can clearly be seen here. Many of the properties have gardens attached to them, a legacy to medieval times.

THE MODERN SCENE (above) bears little resemblance to the old one. A few buildings, such as the King's Head, can be identified; however, a significant portion of the Broadway, especially on the east side, has been demolished, including Pinnock's coal yard, David Collings' shop and Broadway House. The Broadway – being the centre of the community, both past and present – has been forced to change with the times, although new buildings are largely designed with care. Also, the demolition of buildings has been known to reveal more about Thatcham's history, as was the case when the National School was demolished and an archaeological excavation took place.

ST MARY'S CHURCH

ST MARY'S CHURCH, *c.* 1955. This church is believed to have originated from around AD 675. It is commonly believed that the Saxons erected a wooden church near, or on, the present site. Then sometime after the Norman Conquest, probably around 1141, the church was rebuilt in stone. At this time, it would have been a rectangular building, essentially the core, or nave, of what can be seen today, and measured 66ft by 21ft. The chancel was built in about 1220 by Abbot Simon of Reading, the church having been presented to Reading Abbey in 1123. The lower part of the tower was built in the fourteenth century, but possibly due to the Black Death, work stopped and the upper part was not completed until early in the sixteenth century. The North Isle was built in 1480 and the Danvers Chantry Chapel in around 1520. It is not clear when bells

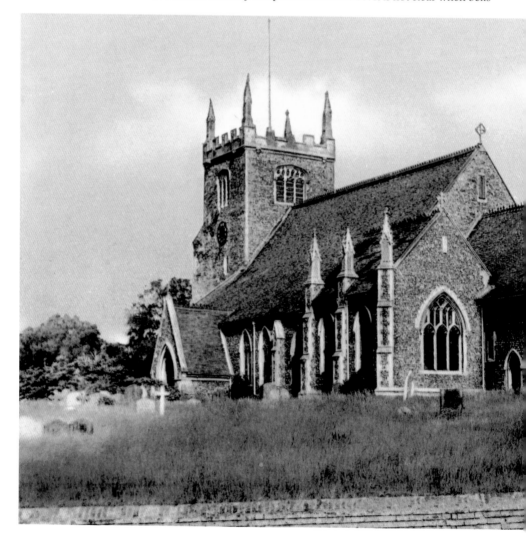

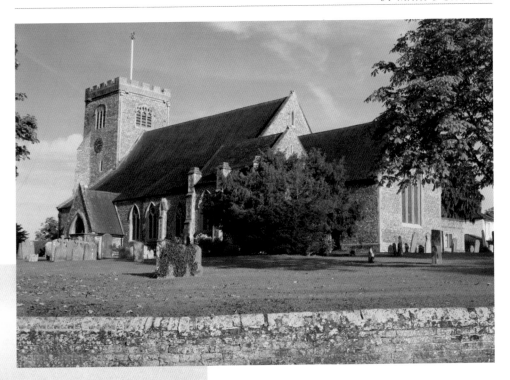

were first installed, however, it was sometime before 1566 as repairs to the bells are mentioned in records from this year. A large renovation was undertaken by Thomas Hellyer in 1857, creating, for the most part, the church we see today. The church was known for a period as St Luke's and, indeed, there is a carving of St Luke on the pulpit. It reverted to the title St Mary's by the end of the nineteenth century. The church has many of Thatcham's former residents buried in it, including Francis Baily, who had been offered burial at Westminster Abbey. The last burial in the church was that of A.S.B. Tull in 1954. *(Reproduced by permission of The Francis Frith Collection)*

WHILE THE CHURCH has undergone significant alteration over the last several hundred years, little change has been seen in the last sixty years. The only modern change, as can be seen from the photographs, is the removal of the pinnacles. The pinnacles on the tower were removed in 1970 for safety reasons, and the ones on the remainder of the church were removed a year or two later to maintain the same style.

THATCHAM MOOR

A VIEW FROM St Mary's Church tower looking south towards the Ordinance Depot, *c.* 1980 (right). Thatcham Moor, now referred to as 'the Moor', was common land. In the fourteenth century, the vicars of Thatcham had land in various locations including La Moure, or the Moor. The fields surrounding Thatcham, including the Moor, were enclosed under the Enclosure Act. Records show land on the Moor going to the Mount and Wheeler family as well as to the Church. The land, however, stayed relatively free of development, although a significant portion was used for the Ordnance Depot for a time.

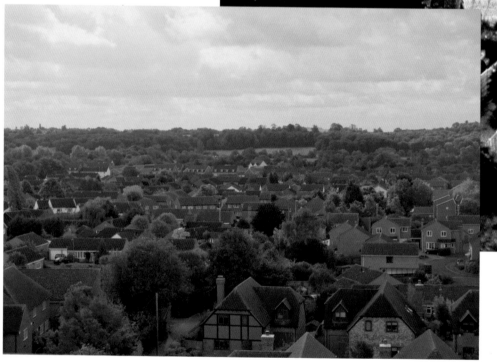

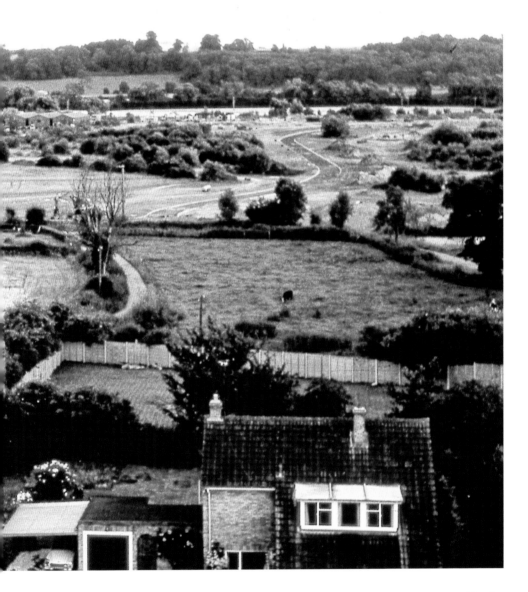

DEVELOPMENT ON THE Moor was granted by July 1977 and covered 81 acres. Additional land for development was provided by Thatcham Farm and increased the development area to about 125 acres, enough room for 1,375 houses. By 1979, people had started to move into houses on this new development, although it was not fully complete until 1987. Green fields still exist in the distance, but most are now housing estates.

THE BROADWAY
FROM STATION ROAD

A VIEW OF the Broadway, looking north from Station Road, *c.* 1913. The Broadway has been home to many charities; on the right of the old photograph, just out of view, was John Hunt's 'poor folk' cottage, which was rebuilt in about 1830 into two cottages, numbers 38 and 39. These almshouses become vacant at the end of the 1970s and by 1987, the cottages were demolished to make way for the Broadway Courtyard. This can just be seen on the right of the modern photograph. It was

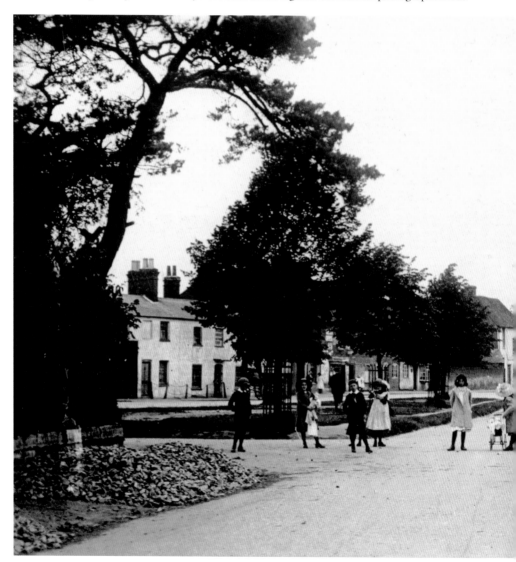

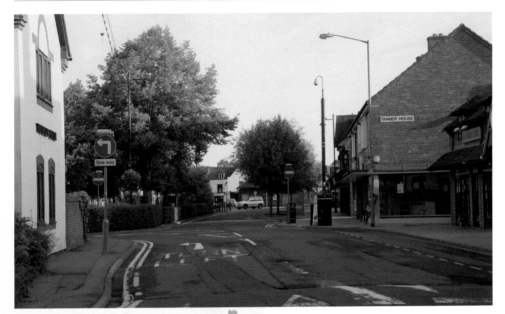

officially opened by D.J. 'Diddy' David Hamilton on 28 May 1988, although the first business to open was Paul Charles Hairdressers, opened by Michaela Strachan in January 1988. *(Postcard supplied by Graeme Stewart)*

TODAY, THE BUILDINGS in the centre, including Thatcham Jewellers, remain but many others were replaced. The Broadway has always been a mixture of residential, industrial and commercial properties, but as demonstrated above, many of the residential buildings have been pushed away from the Broadway to make way for commercial outlets. Next to the almshouses was the old workhouse and on the left was a small cottage. Today, there is a new building housing Gardner Leader, solicitors. The building is known as Winbolt House, after the last master of the workhouse, Edward Winbolt. Taking a closer look at the old view, it is clear that pathways were not really in existence and the road conditions were far from what they are today.

THE WORKHOUSE
& WOOD TURNERY

THE SITE OF Thatcham's former workhouse, *c.* 1905. The chimney in the centre of the old photograph belongs to one of Thatcham's wood turneries; today the site is part-occupied by Wagtech International Ltd, and the other part is residential. The premises are actually in Station Road and not the Broadway. The wood-turning trade was, at one time, one of the major employers in the village. This particular one was in operation around 1815, with Stephen Pinnock being the proprietor. John Brown & Sons took over the business in 1889, after setting up a previous turnery in 1847. Employees were treated to a dinner in 1947 to mark the business' centenary.

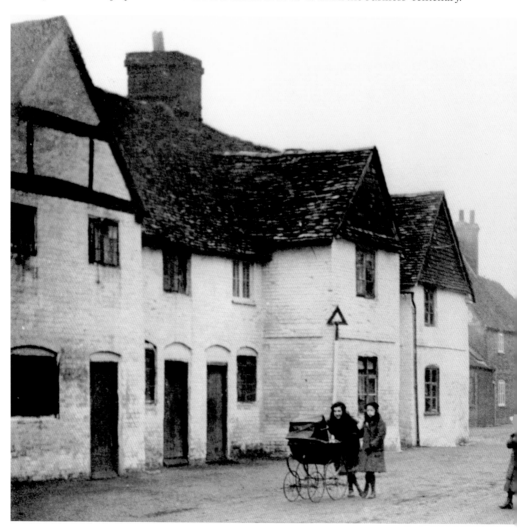

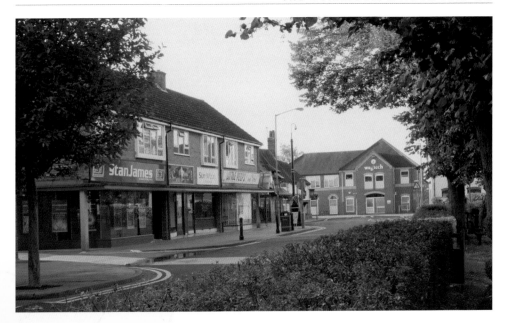

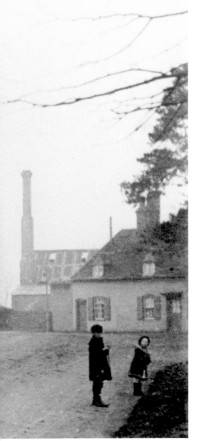

However, the business was amalgamated with that of Collins & Witts in 1958 and all work was transferred to the turnery in St John's Road. The site in the Broadway was then used by Bridgnorth Milk Transport, before being taken over by Frank Edwards in the late 1970s. The business continued until 1985, and by 1987 the site had been demolished and a residential area, Nideggen Close, built. The building on the left was the workhouse, dating back to 1782 or earlier. The last master of the workhouse was Edward Winbolt, who died in 1835, and the workhouse closed in 1837. By this time, Newbury Union Workhouse would have taken in the poor from the surrounding area, including Thatcham. The workhouse was eventually split into four cottages which survived until 1959, when they were demolished to make way for a new parade of shops known as Tanner House. These were officially opened in 1960 by John Slater, from the TV show Z Cars.

TODAY, TANNER HOUSE occupies the grounds of the former workhouse. Several businesses can be found in this building, including Stan James, Greenalls Barbers and Skin Wizard. Next to this is the Broadway Courtyard, which has several more shops, including Paul Charles Hairdressers, Mandarin Court (Chinese takeaway) and Sticks and Strings. At the end of the road is the Old Chequers pub, which remains a popular venue for locals.

PINNOCK'S COAL MERCHANT

PINNOCKS COAL YARD in 1920 (below), with one of the early trucks in the village. Not a local family, originally Stephen Pinnock came to Thatcham in around 1810 and established a wood turnery. Stephen's wife, and then sons, took over the business after his death. At one time, there were six Pinnock families living in the Broadway and another in the High Street. The family became very active in the local community; Stephen's grandson, Stephen Raymond Pinnock, became involved with the Parish Council. Some of Stephen's sons set up their own businesses. Stephen Pinnock (junior) established himself as a brush maker in Station Road, and Edmund Pinnock set up as a coal merchant in the Broadway. Initially, he worked for his father in the wood turnery but by 1869, he was well established as a coal merchant, located at No. 50 the Broadway. He was also

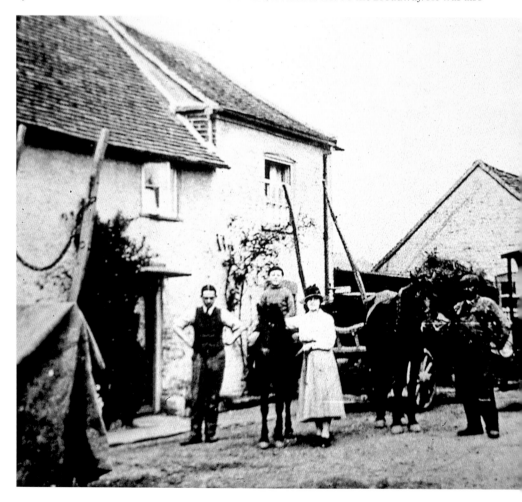

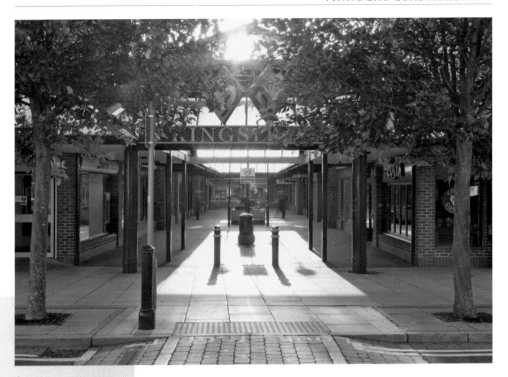

appointed the local GWR agent. Edmund's son, Frank, took over the business followed by *his* son, Edmund Thomas Pinnock. This 1920s view shows the coal yard with Edmund Thomas Pinnock and Eva Pinnock standing either side of the pony, called Kitty. The boy on the pony is Eva's nephew, Reg, and the gentleman standing with the horse is Mr Headlong, who worked his entire life at the coal yard. The couple had two horses, Tommy and Major, although as can be seen here the automobile had already started to come into use. The land was bought in the 1980s, together with land from Brown's garage, and by 1985 it had become the Kingsland Centre. Pinnock's last day of trading in the Broadway was on 2 November 1985, after which they relocated to Pipers Lane, which itself was undergoing development at the time.

PINNOCK'S IS ONE of the few old businesses still trading – now as suppliers of home-heating oil. The Kingsland Centre now occupies the former site of Pinnock's. It is a partially covered shopping area with benches and raised planted boxes. In the centre, Waitrose supermarket can be found, as well as many other shops including Lloyds TSB, Kingsland Café, Costa, Age UK, and Ziggy's Hairworks – a good variety, although not the range that once existed. At the back is a large car park that connects to The Moors road and gives plenty of footfall for the shops in this stretch of the town.

TOMLIN FOUNTAIN

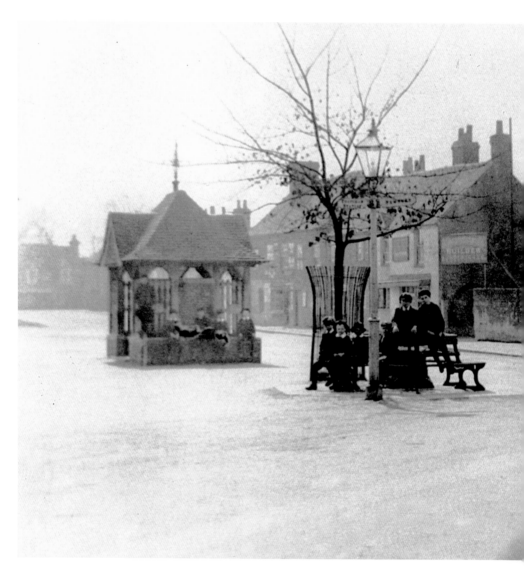

THE BROADWAY, LOOKING south (above), with the Tomlin Fountain and butter cross, *c*. 1915.
The butter cross was not the only historical feature in the centre of the Broadway. In 1896,
Councillor John Henry suggested planting trees around the green as part of, or in preparation for,
the celebrations of Queen Victoria's Diamond Jubilee. The council eventually agreed to the planting
of lime trees; however, it was not until October 1897, after the jubilee. In 1900, to mark the turn
of the century, Thatcham Parish Council had an oak tree planted, which still stands today. The
tree was supplied by Miss Annette Henry. At this time, at the Annual Parish Assembly, Mr John

Henry noted that the green was 'in a sad state and a disgrace to the parish', apparently due to schoolchildren playing on the green. Ann Tomlin of Sydney Lodge, Station Road, paid for a fountain in the Broadway. It became known as the Tomlin Fountain and was opened in 1911, dedicated to

the memory of Edward VII and to the coronation of George V. The water was supplied from a 140ft-deep well. The first public toilets were built adjoining the Tomlin Fountain in 1939, by which time it was no longer supplying water. The fountain, well and toilets lasted until 1969, when they were demolished – perhaps as part of Thatcham's drive to win the Best Kept Village award, a title it claimed in 1972.

A NEW TOILET block, designed by a man from Newbury, was built in 1970, and a clock added in 1971, although the population of Thatcham did not take to its design well. This toilet block was then demolished on 24 October 1996, and the current toilet block built in 1997, the north wall retaining the original dedication from the Tomlin Shelter. The last alteration to this part of the Broadway was the Millennium Monument, erected in 2000. The monument has a short timeline of Thatcham's history on it, using facts supplied by Thatcham Historical Society.

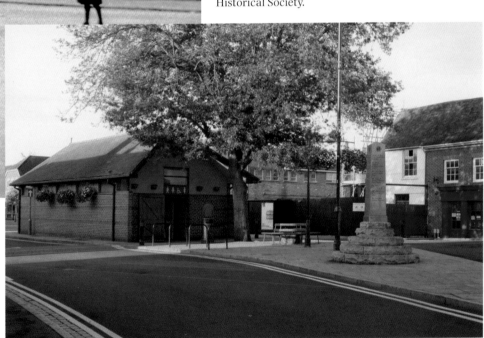

THE RELIEF ROAD

PRIOR TO 1962, the A4 from London ran to the top of the Broadway and then through the High Street. The section of Chapel Street between the Broadway and the point where the High Street re-joins the A4 did not exist. The junction between the A4 (Bath Road) and the Broadway was a well-known bottleneck causing many problems, including cars and trucks crashing into buildings – the White Hart in particular. A relief road was suggested around 1951, although work did not start until around 1960. Part of the new relief road required the lower part of Park Lane to be demolished, along with other buildings. Smart's fish and chip shop and a hairdressing salon, as seen in this glimpse from 1950 (right), were demolished, as well as B.J. Brooks' corn store in Park Lane.

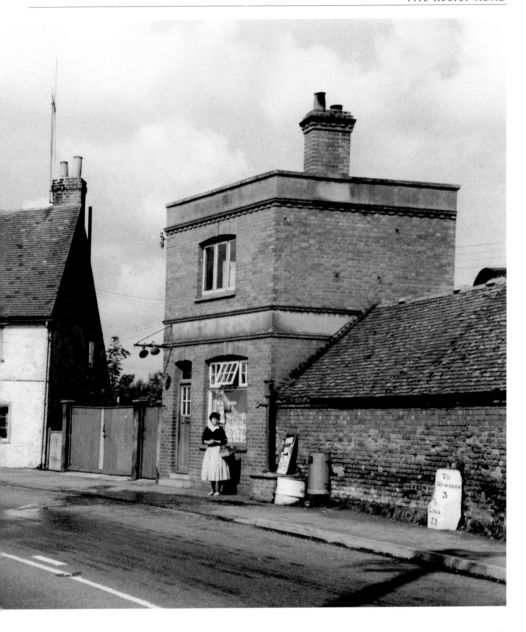

TO INCREASE SAFETY and allow pedestrians to cross the relief road, a subway was constructed. Its design was intended 'to reduce as much as possible the tunnel-like effect which to a certain extent is inevitable.' This was done by letting in as much daylight as possible and using light-coloured panels. It was illuminated night and day by six electric lamps. Sadly, just a week after the relief road opened, there was a fatality. The council had suggested that the new road be one way, west to east, and that the old road flow in the opposite direction. Thankfully, that suggestion was turned down. A junction now sits here with the relief road cutting through the old buildings.

CHAPEL STREET

CHAPEL STREET, LOOKING east from near the Wheatsheaf in 1955 (below). On the left, the old Raleigh cycle shop can be seen, which in the 1930s, and later, was owned by Mr Gilbert. Although their main trade was bicycles, he also sold wirelesses and gramophones. In the 1980s and '90s, there was still a cycle shop here. Recently, however, it has become Forrester's Hair and Beauty. A few doors down is the Wesleyan Methodist Chapel, known today as the Methodist Church, which was opened in 1834. This was previously a brush turnery works. The church grew in popularity and in 1880 it was enlarged. In 1902 a school room was added and in 1970 further expansion was completed. Next door was the police station, which opened in 1905 with Sergeant Daniel Goddard in charge. The station retained a number of police officers and even gained numbers. In 1969, the station was closed and it stood empty. Thatcham Town Council moved in during 1976 and remained there until 1984, when they moved to new offices in Brownsfield Road. At this time, the police moved back into the building, although only part time. Later, the police closed it to the

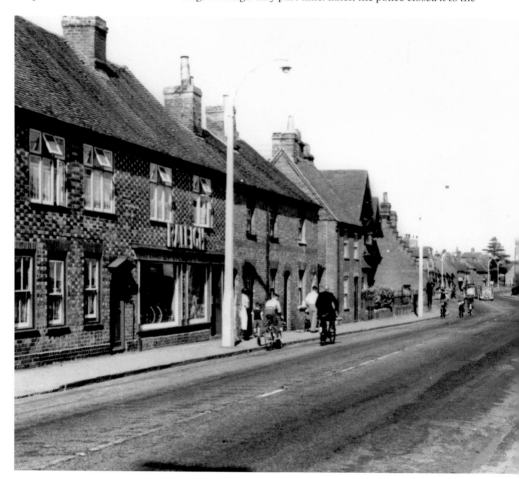

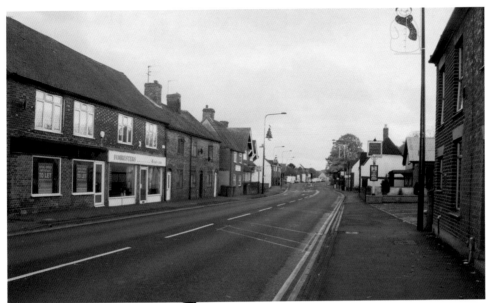

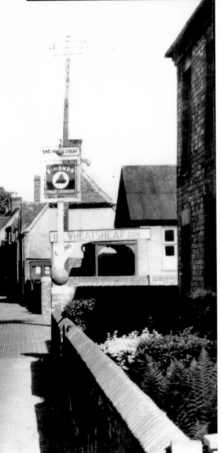

public altogether to be used as offices. Further down, the thatched cottages and the old Bluecoat School can just be see in the middle distance. On the opposite side of the road was a butcher's shop. In 1881, this belonged to Frank Wise, who had previously occupied the New Inn. In 1924, there was another butcher there, Harry Colburn. Next door was the Wheatsheaf pub. In 1830, the landlord was Richard Tuggy, but before this date little is known. The pub was pulled down and rebuilt in 1927. It has since celebrated many events with the community, including coronations. The next building along is the Parish Hall, built in 1907. The hall was used as a library from 1924 until about 1967, when it was moved to the Memorial Hall. The hall has been used, and continues to be used, for many events, and was used as a classroom in 1958 when Kennet School was overcrowded. *(Postcard supplied by Graeme Stewart and reproduced by permission of The Francis Frith Collection)*

THE GARDEN IN the foreground on the right of the old picture has now gone and the road has been widened, but otherwise little has changed. Other shops which occupied premises further down included sweet shops and a tailor's, as well as a blacksmith. Today, however, few shops remain.

NINE SHILLING HOUSES

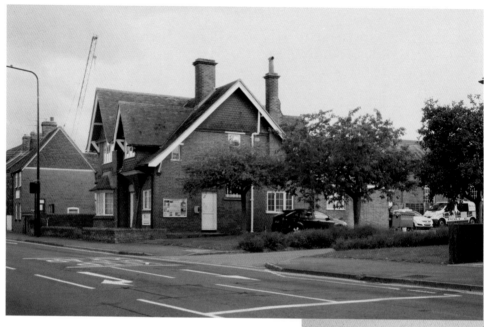

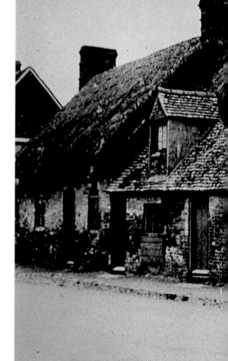

THE NINE SHILLING Houses, *c*. 1900 (right). The Nine
Shilling Houses, or at least the charity, dates to 1585
according to the Thatcham Parochial Charities and were
for the use by the poor of Thatcham. Although the exact
history of the houses is not known, some insight can be
gleaned from a Charity Commissioners report of 1837.
It says here that there were four tenements, referred to as
Nine Shilling Houses, in Duke Street, now Chapel Street.
There is also an entry for a cottage and garden with cow
commons; presumably this is the cottage seen on the left of
the photograph. It has been suggested that it did form part
of the Nine Shilling Houses; however, as it is a separate
entry in the report, presumably it was not at that time.
The almshouses were once part of the Church Estate,
which kept many of the properties for use by the poor,
but was separated in 1899 by order of the Charity
Commissioner, who also requested the charity be
administered by nine trustees. In 1904, No. 20 Chapel
Street, was sold and subsequently demolished. In its place,
a police station was built, which opened in 1905. The

Nine Shilling Houses themselves – the name presumably deriving from the annual rent that may have been paid at one time – were part thatched and part tiled. Here they are shown in a state of disrepair – they were renovated in 1901 at a cost of £80, when the thatching was removed and replaced with tile and an extra dormer added. *(Photograph supplied by Bill Butler)*

TODAY, THE THATCHED cottage has become a police station and the houses have been rebuilt into police houses. The houses survived until 1960, when they were demolished. Houses for the police were built on the site in 1967. A new building named the Nine Shilling House had been built on land in the 'Dip' – land once used for gravel extraction on the junction of Green Lane and Lower Way – and were opened in 1995. Thus, although the original houses no longer survive, the name does and, indeed, they are still almshouses.

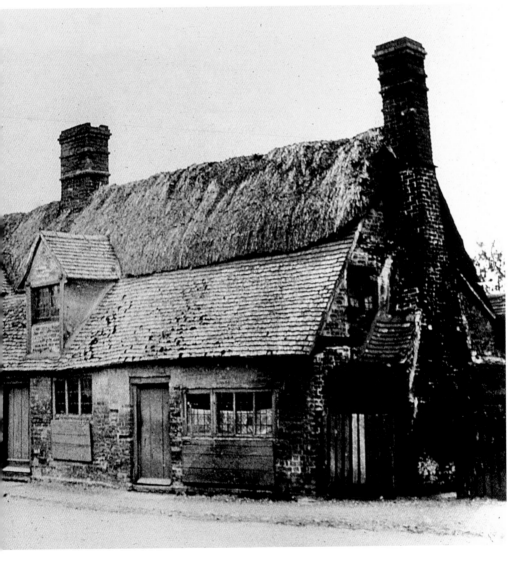

THE MOORS ROAD

THE MOORS ROAD links Lower Way with Chapel Street, although this was not always the case. When built in 1974, it left Lower Way and followed the present course for a time, but stopped after a short distance, close to where the Thackerays is today. Old maps show that in 1911, there was a branch from this point heading south, giving access to the 'Sewage Farm'. By 1932 there was a building, simply called The Bungalow, at the location of the Thackerays. The Moors road was extended to connect to Chapel Street, but it was not officially opened until 1985. *(Photograph by Mike Elliott)*

CHAPEL STREET WAS first tarred in 1902, and then only up to the Turnfields area –

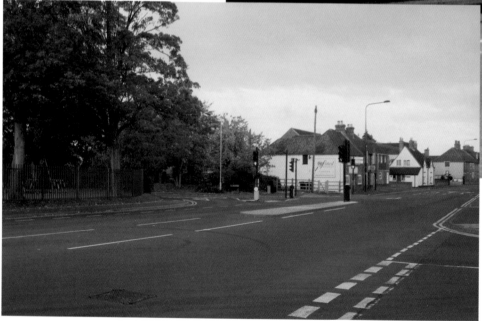

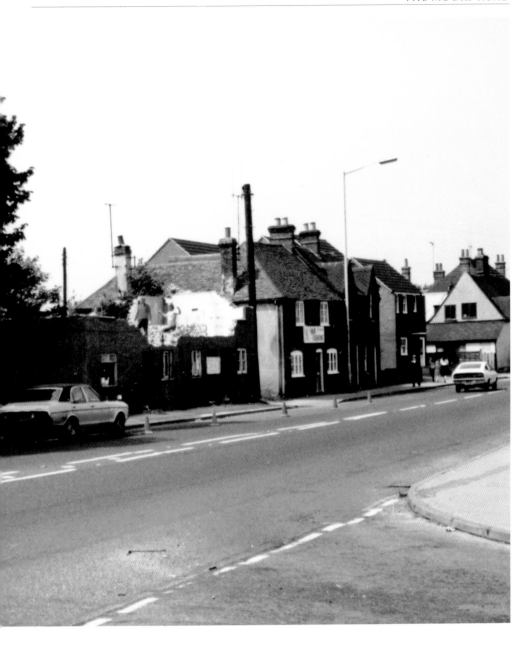

the rest of the road was not completed until at least 1908. The road on the right is Park Avenue, an estate constructed in the 1960s, with this end of the road joining Chapel Street in 1967. To build the junction between The Moors and Chapel Street, several buildings were demolished. On the left is the Turnfield recreation ground. The land, once known as Tunmede and presumably later as Tunfield, was given in 1921 to Thatcham Parish Council by Arthur Brown, for use as a playground for children. In 1935, to celebrate the Silver Jubilee of George V, a shelter was erected, however, in 1975 it had been so badly vandalised that it was demolished.

THATCHED COTTAGES

THE THATCHED COTTAGES, looking east along Chapel Street, *c.* 1960. Chapel Street is full of historic houses, many of which remain to this day. On the left of the photograph are the Thatched Cottages, numbers 66 to 74 Chapel Street. They were built sometime in the seventeenth century to provide income to support the Loundyes almshouses, which lay on the opposite side of the road. Next to the cottages, No. 64, on the west side, was a blacksmith's shop belonging to George Pike. Around 1930, the houses were renovated and continued to be rented to poor families of Thatcham. In 1972, after the last resident died, the houses were sold off, partly due to the state they were in. The houses were modernised and converted from five dwellings to four. They were then sold into private ownership. On the same side of the road, just before the Bluecoat School, is Bluecoat House, which was built around 1870 for its headmaster. Just before this was Marsh House, built in 1794. It has been home to many notable families. The last owner, prior to its demolition in 1972,

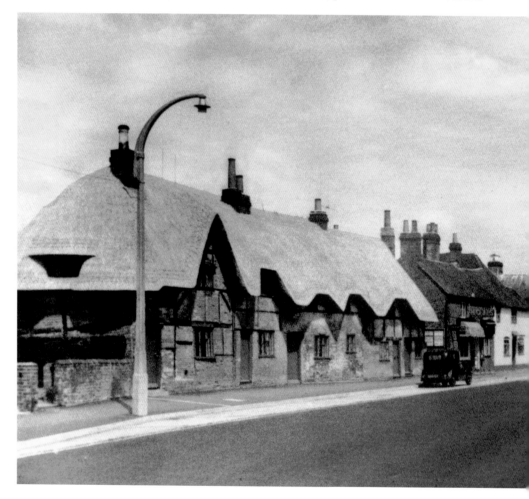

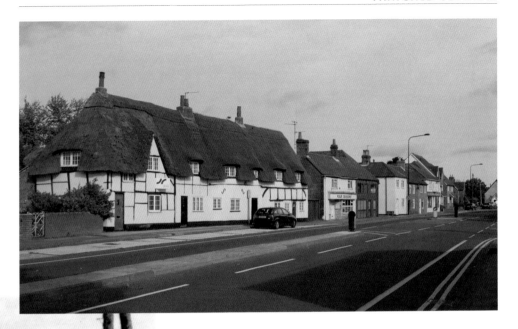

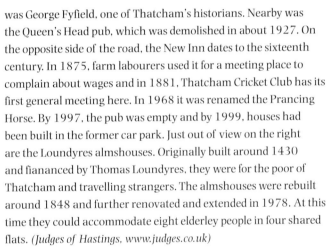

was George Fyfield, one of Thatcham's historians. Nearby was the Queen's Head pub, which was demolished in about 1927. On the opposite side of the road, the New Inn dates to the sixteenth century. In 1875, farm labourers used it for a meeting place to complain about wages and in 1881, Thatcham Cricket Club has its first general meeting here. In 1968 it was renamed the Prancing Horse. By 1997, the pub was empty and by 1999, houses had been built in the former car park. Just out of view on the right are the Loundyres almshouses. Originally built around 1430 and fiananced by Thomas Loundyres, they were for the poor of Thatcham and travelling strangers. The almshouses were rebuilt around 1848 and further renovated and extended in 1978. At this time they could accommodate eight elderley people in four shared flats. *(Judges of Hastings, www.judges.co.uk)*

TODAY, APART FROM Marsh House and the Queen's Head, little on the north side of Chapel Street has changed. Many of the buildings remain, with a few exceptions, and some, like the Loundyres almshouses, are still used for their original purpose. The thatched cottages remain in private ownership and are Grade II listed. There is a heavier flow of traffic and hence fewer pedestrians here in modern times. For these reasons, and perhaps others, there are fewer shops and businesses than there used to be. Two that do still survive, however, are the Four Seasons Chinese takeaway and A-Plan Insurance.

THE OLD
BLUECOAT SCHOOL

A VIEW LOOKING east along Chapel Street at the Bluecoat School, *c.* 1955 (below). By the start of the fourteenth century, St Mary's Church had become unable to cope with the growing population of the borough of Thatcham. Remember, at this time the church would have consisted of just the nave, chancel and the lower half of the tower. Thus it was decided that a chapel should be built at the eastern edge of the village. The chapel was completed by 1304 and was referred to as the 'Chapel of the Borough' and St Thomas's Chapel. The chapel remained in use until around 1540, after which it appears to have been abandoned – perhaps because St Mary's, by this time, had been significantly enlarged, or possibly in connection with the Dissolution of the Monasteries, during which King Henry VIII wanted to wipe out the memory of Thomas Becket. In the early eighteenth

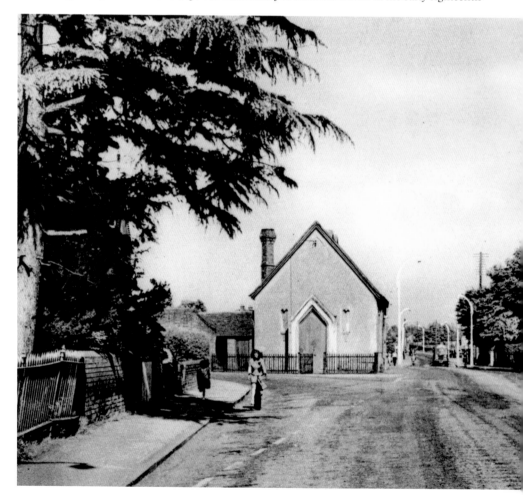

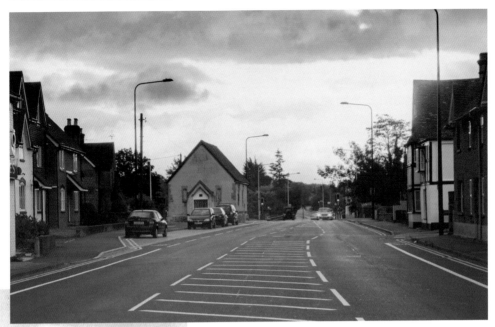

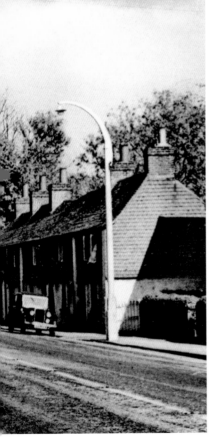

century, Lady Frances Winchcombe acquired the chapel. In a trust deed dated 30 June 1707, she then gave instruction for conversion to a school for thirty poor boys of Thatcham, Bucklebury and Little Shefford. The connection with the latter was severed in 1926. Lady Winchcombe died days after this deed is dated and the school became known as Winchcombe's Charity School. In the early years, the school was mismanaged by the trustees; indeed, it was barely opened until after 1713 and then only until 1730, when it closed. Despite efforts being made in 1752, the school did not re-open until 1794, under schoolmaster John Blay. It is from this period the school became known as the Bluecoat School. By 1825, there were about 100 boys in attendance. *(Postcard supplied by Kath Nailor and reproduced by permission of The Francis Frith Collection)*

THE VIEW TODAY looks similar (above), although Marsh House on the left has gone and so have the buildings at the rear of the school. The school was no longer in use by the late 1960s, and it was subsequently sold to Newbury District Council. Repairs were undertaken and, by 1974, it was being leased for retail. The last tenant was an antique dealer. The school is now in the hands of a charitable trust, which today is working to raise funds to restore it.

THE MARSH

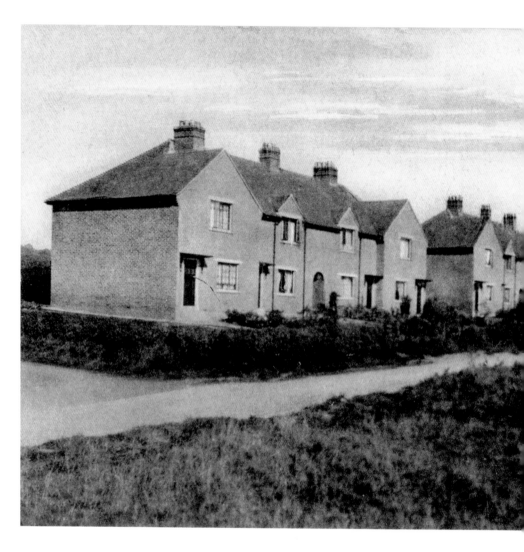

THE COUNCIL HOUSES along Harts Hill Road and the Marsh, *c.* 1926. Dunstan Green was, in the sixteenth century, known as Chapel Marsh; for a period as Thatcham Borough Marsh, and, by the eighteenth century, simply Thatcham Marsh. This then became shortened to 'the Marsh'. By the time the council houses were built in 1926, it was known as Dunstan Green. On the north and east sides was a ditch and stream, which still runs there today. There was also a pond on the green but in 1928 it was filled in. The stretch of road from Chapel Street to the bridge at the top of Dunstan Green was officially named Winchcombe Road in 1928, and the name survived until 1957. During this period, as a result of the council houses being addressed 'Dunstan Green', the road was often referred to as Dunstan Road. Harts Hill Road already existed but was only the name of

the road that extended north of Dunstan Green. In 1964, this was changed and the name applied to the whole stretch of road back to Chapel Street. The green itself has been used for many events. Games of cricket are recorded as far back as 1786; one match in 1793 saw Thatcham winning a

game against Newbury! A cricket club was established during the reign of Queen Victoria; the club named itself Thatcham Victoria Cricket Club. The name changed in 1881 to Thatcham Cricket Club. Cricket continued to be played on Dunstan Green until 1920 and the club moved in 1921 to an area of land in Park Lane. Football was also played on Dunstan Green. In 1894, Thatcham Football Club played their first recorded match, using the nearby Plough Inn as their base. Other events taking place on Dunstan Green included the annual bonfire, circuses and fêtes. *(Postcard supplied by Graeme Stewart)*

THE MODERN VIEW (below) shows the houses along Harts Hill Road with the many buildings that have been newly built and/ or altered since the 1930s. The front gardens of the older houses have long since disappeared to become car-parking spaces. The road now sees a lot of traffic, as it gives access not only to Bucklebury but also to the new housing estates in the north of Thatcham. The Marsh itself remains a green, open space and is used for events, including Thatcham Classic Car Show, which is part of Thatcham Festival of Art and Leisure. Just out of view is a children's park and a skate park.

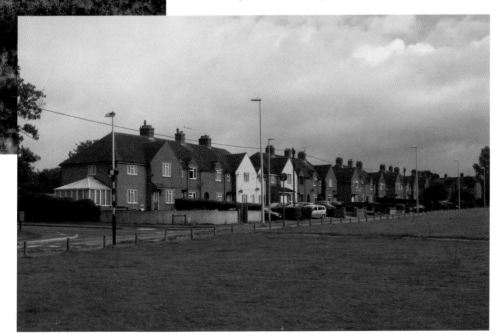

HARTS HILL ROAD

LOOKING NORTH UP Harts Hill Road in 1904 (right). The name Harts Hill Road dates back to 1675, although it was also referred to as Bucklebury Road in 1817. The origin of the name Harts Hill Road is unclear. Roy Tubb suggests that it may be because of the family name 'Hert', of which there was a 'William le Hert' associated with St Thomas's Chapel, in 1307, and in 1367 a John Hert who lived in lands owned by Colthrop Manor, including land alongside Harts Hill Road. It would appear the road may have therefore started as Herts Hill Road and over the years been changed. On the left is the entrance to Harts Hill Farm, although today this leads to a small industrial estate together with a residential estate. Thatcham was once full of farms; today only a handful remain. In 1847, John Adnams is recorded as the farmer at Harts Hill Farm. Robert Wyatt, who owned and ran the family butcher's shop in the Broadway, took over the farm in 1914. This was probably a dairy farm at the time, as he was providing dairy produce at his butcher's shop. In the 1970s, the farm was home to Mr and Mrs John Simmons. During the Thatcham Folk Festival of 1970, two of the barns at the farm held 300 dancers at a square-dance event.

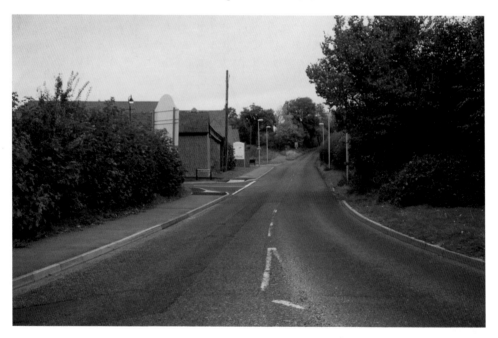

TODAY, THERE IS a residential estate with some small industrial buildings where the farm used to be. The road has been widened, which probably accounts for many of the trees changing between the two scenes. Further up the hill is a site that makes Thatcham important, archaeologically speaking. Excavations uncovered evidence of Bronze Age, Iron Age, Roman and medieval settlements. Significantly, some of the iron working was dated to around 1,000 BC, about 250 years before the Iron Age is generally thought to have started.

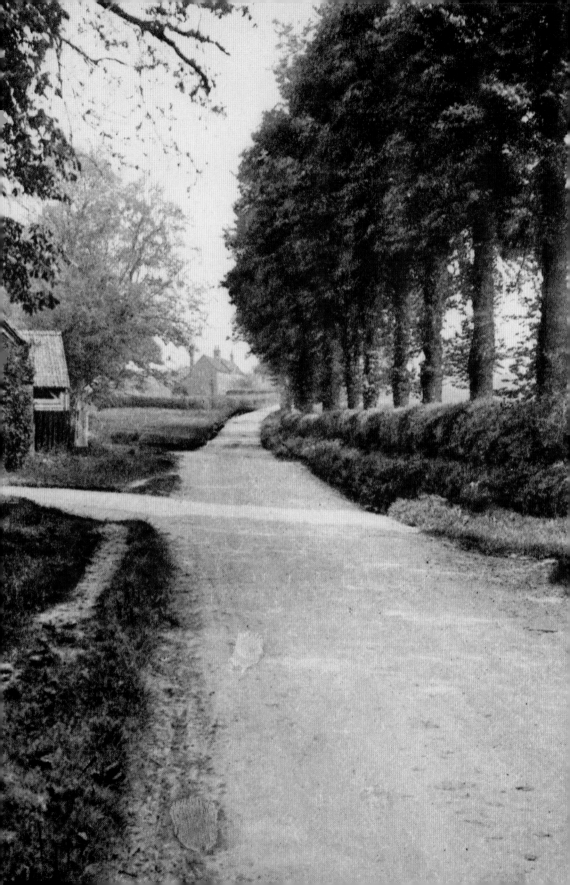

THE LONDON ROAD

A VIEW LOOKING along the London Road, towards Reading, from the Marsh, *c.* 1915 (right). The Plough Inn still stands, but the houses along the road have long since gone. In the foreground, the pond that was once present on the Marsh can be seen; it was removed in 1928. The newly built council school is in the distance, but in 1881 there were perhaps only three cottages east of Stoney Lane. At this time, somewhere near the Plough Inn, was a blacksmith. Even in 1915, there was little in the way of buildings east of Stoney Lane. Today though, there are many buildings along this stretch of road. The Plough Inn, which dates to the seventeenth century, can be seen in both photographs and has hardly changed. The

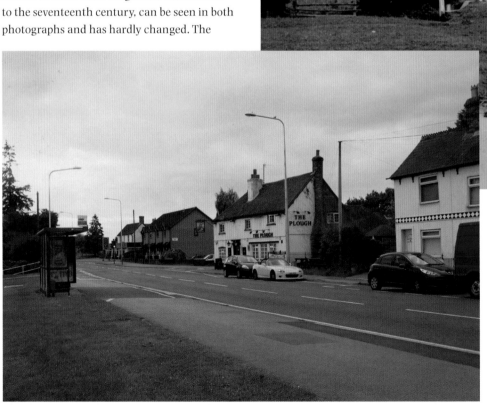

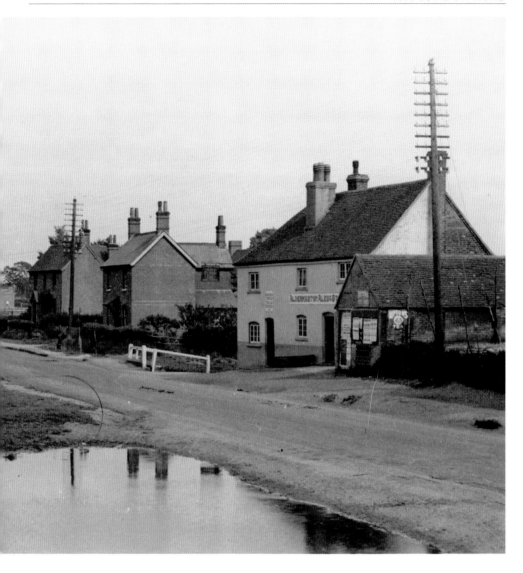

older scene shows an advert for some of its drinks, including those from Aldermaston Brewery. *(Postcard supplied by Graeme Stewart)*

THE WHITE RAILINGS show the entrance to Stoney Lane, when it was just a lane. Today, the railings are gone and the lane is a proper road. The name Stoney Lane dates back to 1547 and there is mention of a watercourse that ran along the lane; presumably this was the Floush. From 1851, it was also known as Watery Lane and sometime during the Second World War it became known as Plough Lane. It was not until 1955 that the original name, Stoney Lane, was restored. At the bottom of Stoney Lane is Kennet School, which opened in 1957. Around this time, other residential properties were being built both in Stoney Lane and along the London Road.

ROSE GARAGE

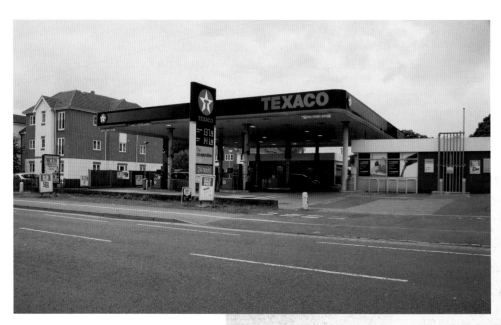

ROSE GARAGE AS it was in 1934 (right). The people of Thatcham adapted to motorised travel quickly; Browns for example diversified from cycles. In 1919, Frederick Spanswick had established a motor coach business and also Thatcham Road Transport Service in 1921. Road traffic, both local and passing, was increasing and hence petrol stations were required. Rose Garage was located along the London Road. In 1934 it was run by the Robinson brothers, who can be seen in the photograph. The early garages were certainly not self-service. They advertised 'easy pull-in, convenient oil cabinets, electric pumps and well-equipped workshop'. Further west was another petrol station, the Excelsior Filling Station. Also operating at the same time was the Excelsior Tea Rooms. The bicycle was still very much

the main transport for many, and a tea stop would surely have been a welcome break. (*Reproduced with permission of* Newbury Weekly News)

THE SITE OF Rose Garage has remained as a petrol station; it later became the Station Supreme and today is the Texaco garage – sadly no longer a local business. Today, there are few places along the main road for cyclists to stop for refreshments; indeed, even the petrol stations have changed significantly. In the past you could have pulled in, had someone fill the petrol tank up and check your oil and other essentials, and there would have also been a range of brands available. Sadly, this service has long gone; the forecourt is roofed over and the whole system is now self-service, with only one brand available. You will still find people cycling around Thatcham today, though perhaps not in the same sort of numbers as in the past. There are, however, cycle paths around Thatcham, which makes it a lot safer.

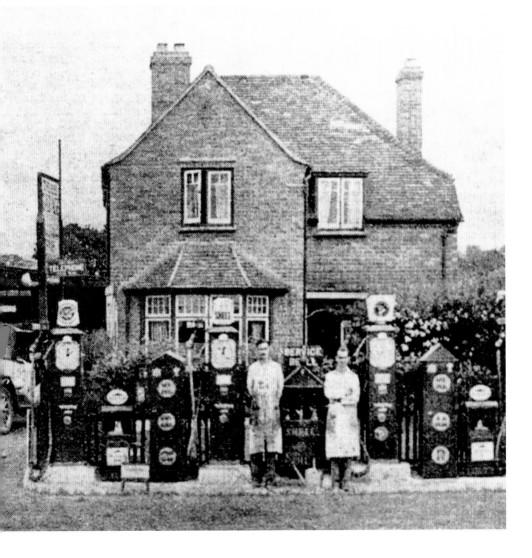

FRANCIS BAILY SCHOOL

THE COUNCIL SCHOOL, as seen *c.* 1913 (below). By 1910, the British School in Church Lane had become very successful; however, it no longer met the standards of the Education Department and required a new playground, among other things. Due to limited space in Church Lane, it was decided that a new school would be built. In 1913, pupils from the British School transferred to the new Council School on the London Road. At the time it opened, pupils in classrooms on the south side could look out across fields, a view that sadly no longer exists. There were five classrooms, which could hold a total of 200 pupils. Not only was the school larger and more modern, it also had a large playground. The headmaster was Mr Horatio Skillman, who was transferred from the British School. He was assisted by Miss Hettie Peters, Miss Eleanor Pinnock, Miss Rhoda Pearce, Miss Kate Ashman and Miss Mayors. Mr Skillman was forced to retire in 1922 as he had reached the age limit imposed by the Education Authority. During the Second World War, some of the children evacuated from London ended up in Thatcham. They too had to be educated. Thatcham children were taught for

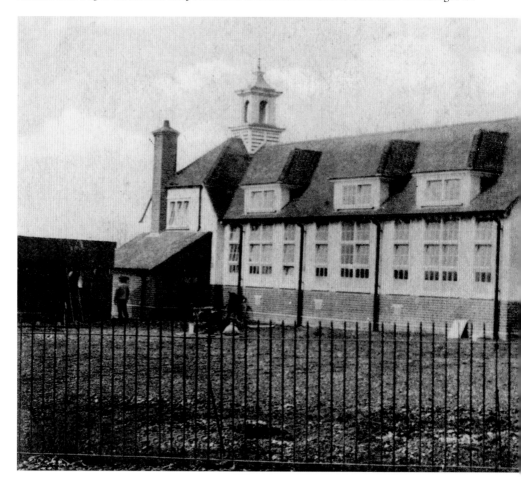

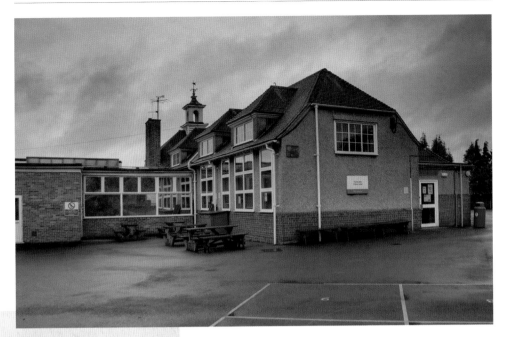

half a day, and then the evacuees for the other half. By the late 1940s, there were close to 500 pupils enrolled at the school and additional classrooms were being used, including at the Bluecoat School, the British School and even the Scout hut. The opening of the Kennet School, in 1957, alleviated some of this pressure. The Council School became known as Thatcham County Primary School and all senior pupils (around 200), were transferred to Kennet School. This did not last long as by 1960 the school was again full and new admissions refused. This only changed when the building of new classrooms was completed in 1961. In 1964, under the new headmaster Mr Edward Helmsley, the school was renamed the Francis Baily School and a school uniform was introduced. Pupils were also taken to place flowers on the tomb of Francis Baily (in St Mary's Church) on his birthday. Francis Baily was born in 1774, the son of a Newbury banker. He was involved in the foundation of the Royal Astronomical Society and also discovered 'Baily's Beads'. *(Postcard supplied by Graeme Stewart)*

KNOWN TODAY AS Francis Baily Primary School, the original school building survives, although it has been extensively expanded. The fields that once surrounded much of the school have disappeared and houses now occupy the space. It remains a popular and successful school to this day.

PIPERS LANE

THE ORIGINAL ENTRANCE to Pipers Lane from the Bath Road, *c.* 1982 (right). Pipers Lane was one of the last true lanes to be altered and dates back to at least the early fifteenth century. It has a connection to Poughley Priory in Chaddleworth – an association that goes back to when, in 1185, Reading Abbey granted 122 acres of pasture land to the priory. It is unknown if a farm was set up then; however, by the early nineteenth century the lane was called Pipers Lane, after the farm that occupied some of the land, Pipers Farm. Presumably the owners or tenants of the farm had the surname 'Piper', although it is difficult to find evidence of this. There was certainly a Piper family in Thatcham at that time, as shown by the burial records. *(Photograph by Mike Elliott)*

TODAY, THERE IS a roundabout entering what has now become Pipers Way, leading to both industrial and residential developments. The whole area was developed in the 1980s and Pipers Lane no longer stretches from Station Road to the Bath Road. Pipers Way roughly followed the course of the old Pipers Lane. The land on the eastern side was developed into industrial units; the land on the west was developed into residential estates – 1,033 houses in total – and included the Kennet Lea and Siege Cross estates. This involved the demolition of Pipers Farm.

STATION ROAD

STATION ROAD, LOOKING towards the railway station in 1982 (below). Station Road leads from the southern end of the Broadway down to Thatcham railway station. There would have been a track of some sort to give access to Chamberhouse and Crookham in the thirteenth century. Prior to 1847, the road was also known as Crookham Road and Long Lane. Although it was long, and only a lane, there were still properties lining it. Near the station was the Swan Inn and near to

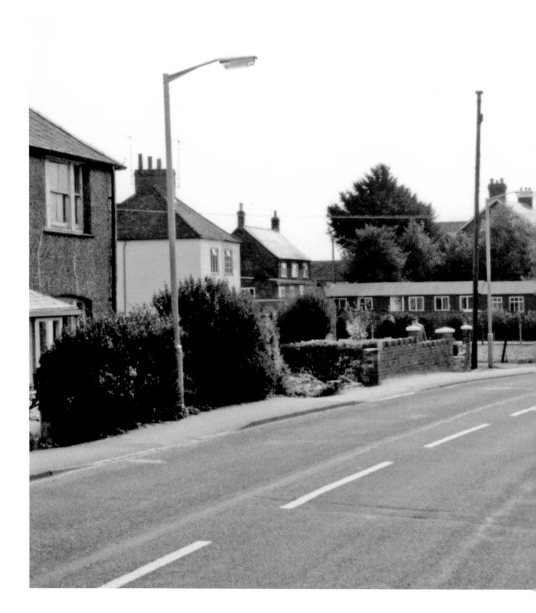

Stoney Lane was a parade of shops built in the early 1960s. There was also Sydney Lodge, the roof of which can just be seen in both photographs, slightly to the right of the centre. Some time around 1880, Francis Henry Lyon ran a doctor's practice at Sydney Lodge; Ann Tomlin lived there in 1911, and there were many other residents over the years. *(Photograph by Mike Elliott)*

TODAY, NEW BUILDINGS exist on both sides of the road, which is intersected by The Moors road. Several of the houses, including a small terrace known as Spring Cottages, were demolished during 1982 to make way for The Moors road. Five more houses were demolished in 1988, to be replaced by Hollywell Court, shown on the right of the modern photograph.

THATCHAM HOUSE

THATCHAM HOUSE (BELOW), as it was when the Turner family lived there, *c.* 1920. Thatcham House was built in 1869 for the Reverend Hezekiah and Isobel Martin (*née* Tull), on land formerly used as an ancient animal pound. They were in residence by the autumn of 1871. The house consisted of over thirty rooms, and the tower – some 60ft high – is said to be equal to that of the parish church, of which Hezekiah was vicar. There was a gravel drive leading to Station Road on the north side of the house, and even a turning circle for coaches. Isobel was Hezekiah's second wife and together they had eleven children, although one died aged six months. Isobel died in 1881, leaving her husband with thirteen children from his two marriages to cope with. He married for a third time, although his health suffered. Hezekiah resigned as vicar in January 1889, took up residence in Clevedon, and sadly passed away later that year. As a memorial to her late husband, the third Mrs Martin paid for new chimes and a face for the clock in the tower. Officially, the new clock was handed over on the afternoon of Saturday, 22 August 1891. With the family now living

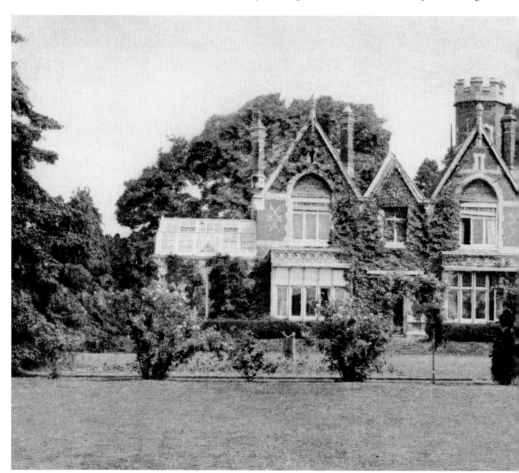

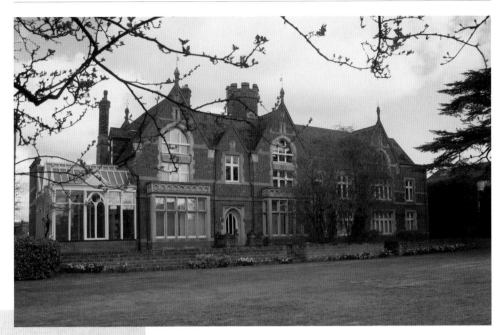

in Clevedon, Thatcham House was sold to John Player in 1889, then to Richard Chattock in 1893, and then on to Major Charles Turner in 1902. Two of Major Turner's sons, Alexander Buller Turner and Victor Buller Turner, were awarded the Victoria Cross for their actions in the First and Second World Wars respectively. Sadly, Alexander died during the war; Victor was injured, but he did survive. The family had moved away by 1948 and in 1951 the house was modernised and converted into three flats. A few years later, Bruno Zornow bought the house and land. Initially, he built himself a house and continued to rent the flats out. During the 1960s, Mr Zornow built more houses on the south side of the grounds and named the development Turners Drive. Building work continued; the fruit trees in the garden were replaced with flats named Orchard Court, and the rose garden gave way to Rosen Court. *(Postcard supplied by Graeme Stewart)*

THE MODERN VIEW (above) shows that externally, the house itself looks the same, although internally a lot has changed and the grounds have all but disappeared. In 1980, Thatcham House had deteriorated to the point where Newbury District Council issued a closing order. It was uneconomical for Mr Zornow to renovate the building to the standards required for residential living, and by 1988 the house, along with the coach house, had been converted to offices.

THE ORDNANCE DEPOT

THE ENTRANCE TO the depot from Station Road in 2000 (below). Charles Clore owned land in Station Road, which in 1938 had W.D. & H.O. Wills tobacco store located on it. However, the army requisitioned the land and opened it as a depot in 1940, under the command of Lieutenant Colonel V.W. Urquart, MC. In 1942, the US army took over and it became the General Depot No. 45, or simply G-45. The depot extended all the way back to Newbury Racecourse and was the largest 'G' depot in the country, carrying supplies of just about everything. Large sheds were erected along with 35 miles of railway track. Around the time of D-Day in June 1944, there were some 7,000 people working at the depot and, by 1946, there were over 8,000 soldiers,

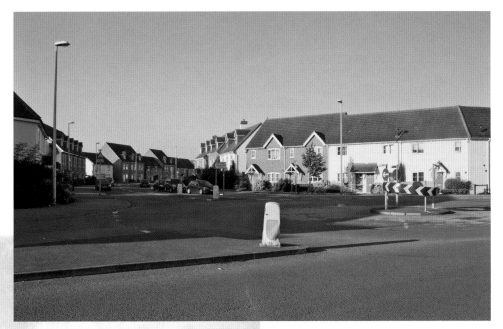

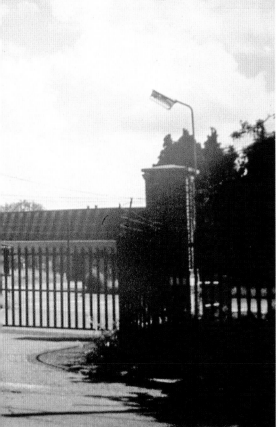

600 civilian employees and almost 2,000 prisoners of war. The depot was handed back to the Royal Army Ordnance Corps in 1946, who continued to use it as a storage and distribution base. By 1958, the depot was employing around 1,000 people, mostly civilians from Thatcham and the surrounding area. The depot maintained a large workforce until 1964, after which cutbacks were made and the number of staff started to decrease. Even so, it still supported many events and campaigns, including the Falklands conflict and the Gulf War. *(Photographed by Peter Allen)*

THE ENTRANCE TO the Kennet Heath estate today is roughly where the entrance to the depot used to be. Closure of the depot was confirmed in 1998; the 'Beating of the Retreat' was held in December 1999 and the depot officially closed in March 2000. Plans were then submitted for a housing estate, which was largely completed by 2010; this estate is known as Kennet Heath.

THE SWAN INN

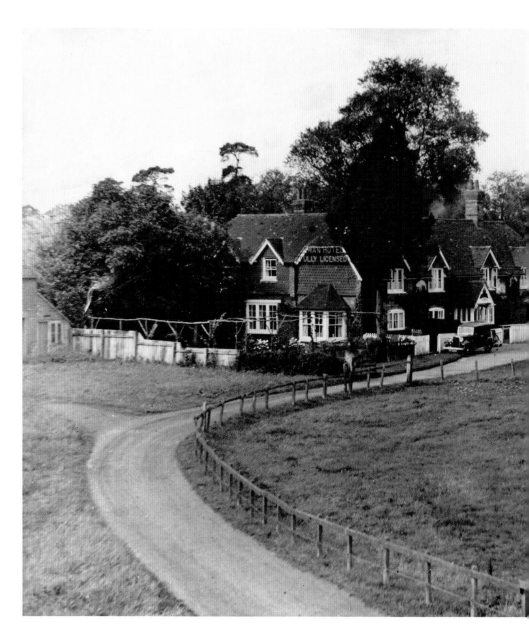

THE SWAN INN, *c.* 1940 (above). From the outside the Swan Inn appears to be a nineteenth-century building; however, it is believed to date from the seventeenth century. Other pubs in Thatcham were also constructed at this time, including the Old Chequers in the Broadway, the Crown Inn located on the High Street, and the Plough Inn along Chapel Street. The inn's structure has probably been

extended over the years and has certainly been modified. The building on the right would have been stables at one time, but today this is accommodation for the bed and breakfast facility operated by the pub. In 1881, the inn was licensed to John Lawes, who, beside being the innkeeper, was a maltster and, in 1883, he was also a coal merchant. The only other maltster in Thatcham at this time was George Mayhew of the Crown Inn on the High Street. In 1881, the Swan was one of only two inns to have a Friendly Society. This was a group where members would make small, regular payments and then when needed – during hard times – the members could obtain aid from the society. *(Photograph supplied by Barbara Smith)*

WHILE THE INN still stands today, it is not without changes. The building itself has been worked on; the old stable block has been converted into accommodation for example. Being situated close to the railway station and the Kennet and Avon Canal, the inn draws in a lot of passing trade, especially in summer months when the grassed area is often busy with people enjoying a drink and meal. Some of the green area has become parking space, while the part to the left of the inn has become a mini-industrial area, with the local Royal Mail sorting office and Anixter Fasteners situated there. The area behind the inn has also become a mini-industrial area known as Crown Yard, with several businesses including Thatcham Tyres and Exhaust, as well as Stewart Walker Ltd, used car sales.

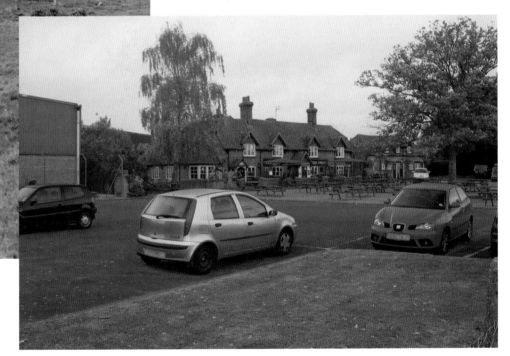

THE RAILWAY STATION

THATCHAM RAILWAY STATION looking west, showing the old goods shed, *c.* 1960 (below). The Great Western Railway (GWR) came to Thatcham in 1847 as the branch line from Reading to Hungerford. The station itself was built on the site of three cottages, which had been destroyed in 1844. The station building was of wooden construction and lasted until 1893, when a new brick building was built. It was situated a mile from the village, a move which is generally credited to Miss Charlotte Maria Fromont. She was the only daughter of Edward and Mary Fromont, who owned and operated the King's Head. Charlotte took over the King's Head after her parents died, but sometime before 1847 she had moved to Thatcham Farm. It is said that she objected to having a railway close to the village, perhaps due to the fact her lands stretched all the way down to the canal. In 1893, there were seven members of staff working under George Fyfield, the stationmaster. By 1948, there were twenty-three staff members, with 120 trains passing through and at least twelve stopping every day. The line used broad-gauge track until 1906, when the line

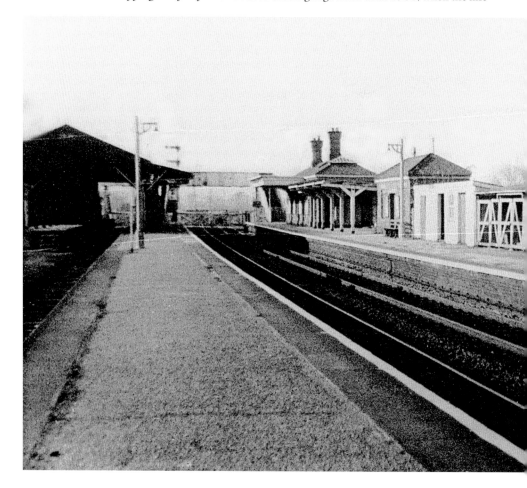

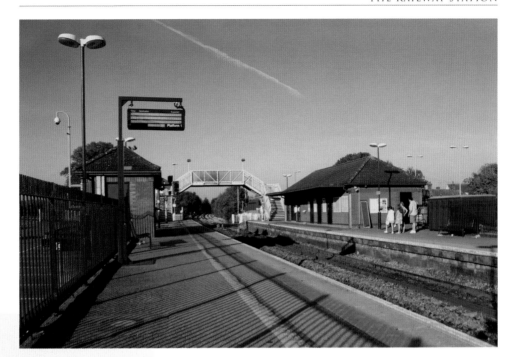

was extended, forcing GWR to switch to standard gauge. Other improvements followed: in 1908 a footbridge was built; in 1915 a siding to Colthrop Mill was introduced; and in 1921 a new signal box was installed. At one point, the nearby depot had 35 miles of railway sidings connected, which stretched all the way across Thatcham Moors to Newbury Racecourse. *(Photograph supplied by Stuart Wise)*

THE BEECHING REPORT of 1963 (which laid out plans to reduce the running costs of British railways, resulting in stations and unprofitable lines being closed) did not go unnoticed in Thatcham, although initially it appeared that Thatcham station may be unaffected. However, it was decided that the station would remain open but unstaffed. All staff were removed in 1965 and, in addition, the goods yard was closed and the station buildings demolished. There were some improvements though; in 1967, the level crossing gates were replaced with lifting barriers and, in 1978, the signal box was demolished when automatic signalling was adopted. Due to the population growth in Thatcham and increasing numbers of people using the train to commute to and from work, a new station and footbridge were opened in 1987. The station has continued to grow and today is busier than ever, with an estimated half a million passengers per year.

THE KENNET &
AVON CANAL

THE CANAL, WITH the railway station on the right and canal bridge on the far left, is shown below in 1907. The River Kennet has been in use since prehistoric times. Our distant ancestors of 8,000 BC would have travelled inland using boats, which would have been much easier than trying to cross the densely wooded land. The river would also have been a source of food for many. There is also evidence that there was once a large lake covering the area. More recently though, in 1723, the Kennet Navigation, connecting Reading with Newbury, was opened. This used the existing river where possible, altering some parts, and in the areas that could not be altered, 'cuts'

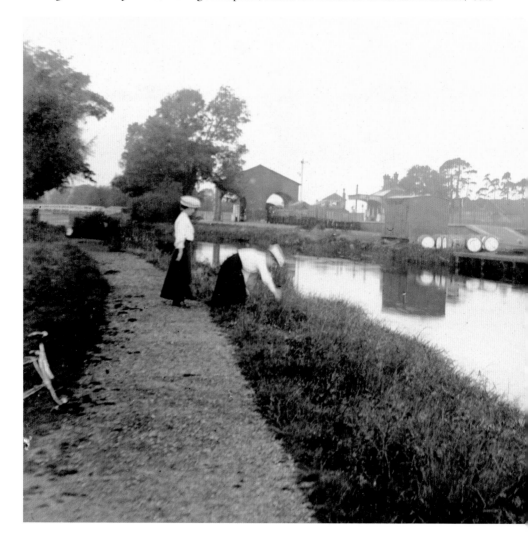

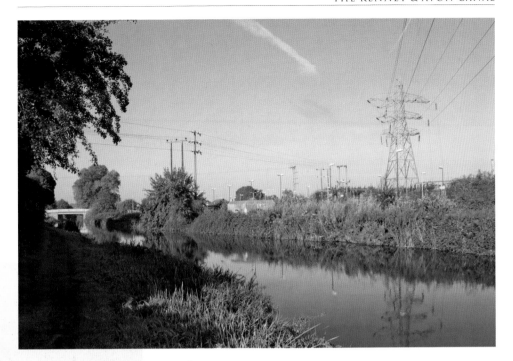

were made, of which there were 11 miles worth. Traffic on the canal included barges carrying meal, malt, flour, beer and cheese, heading from Newbury towards London; and timber, coal, iron and a wide range of imported foodstuffs going in the opposite direction. There was enough traffic to allow for a market boat to be operated in 1725. The waterway was enlarged in the 1760s to allow for the 128-ton Newbury barges to be used. These were crewed by six men and a boy, and used eight to fourteen horses to draw them upstream, but only one to go downstream. The canal was extended and eventually, in 1810, became the Kennet and Avon Canal. The canal became busy as it was a major route from London to Bristol and vice versa. *(Photograph from the Fuller family's collection)*

TODAY, THE GOODS yard and associated equipment have long since gone; the railway station can just be seen behind the bushes along with a sub-station. The coming of the railway in 1847 did impact on the canal; however, it remained in use, even up to the First World War, when canal carrier Jack Garner had a regular trip from Colthrop Mill to Bristol. By 1949, the canal was in poor condition and by 1951, parts had become unusable. The future of the canal was uncertain. In 1962, the Kennet and Avon Canal Trust was formed and work to re-open the canal started. The canal finally re-opened in 1990 and still remains in use to this day.

CHAMBERHOUSE FARM

CHAMBERHOUSE FARM LOOKING north-east, *c.* 1904 (below). Archaeological excavations on land around the farm have found Mesolithic flint blades and a Neolithic axe head. Further work has discovered field systems dating to the late Iron Age and Romano-British periods. This suggests there was a settlement of some description here, the size of which it is difficult to say. What happened between the Roman period and 1250 is unknown. The name Chamberhouse dates back to at least 1250, when reference is made to Roger de la Chambre, who owned the Chamberhouse estate. The road from Thatcham to Chamberhouse was mentioned in 1384 and was referred to as Chambrelane. Around 1445, the Chamberhouse estate, including the house, woods and farmland of some 300 acres or more, was bought by John Pury. A year later, he was granted permission to

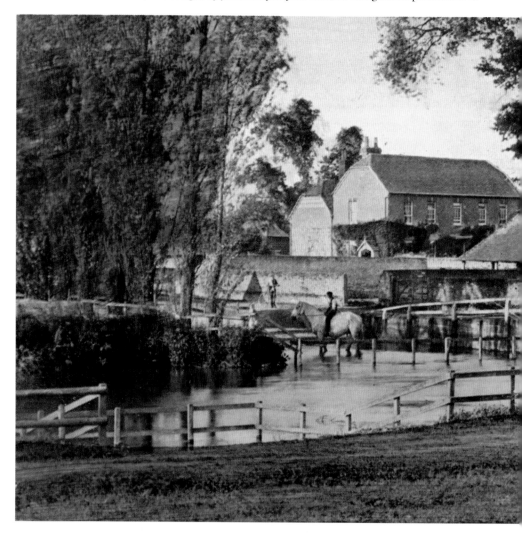

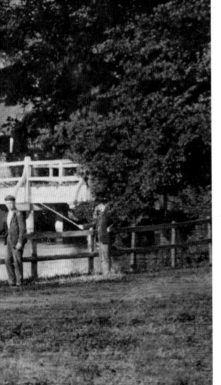

crenellate his home and empark the surrounding land. It is not known exactly how he went about this, however, it is known that a moat was created and thus Chamberhouse Castle was created, although it was technically a fortified manor house. Later, Sir William Danvers owned the estate, through his wife, who was the daughter of John Pury. The Danvers were well known and upon William's death in around 1530, Lady Ann Danvers paid for the building of a chapel at St Mary's Church in memory of her husband. The property passed through various hands, including the Docwras and Fullers. *(Postcard supplied by Graeme Stewart)*

CHAMBERHOUSE FARM LOOKING north (above). The bridge can just be seen on the left, with the trees and bushes now overgrown. Chamberhouse Manor lasted until about 1713 when it, along with the private chapel that had been built, were demolished. Some time during the eighteenth century, Chamberhouse Farm was built. By the end of the century, the estate was purchased by Henry Tull and remained in the family until 1939, when it was sold to new owners. From then until today it has remained a working farm.

CHAMBERHOUSE MILL

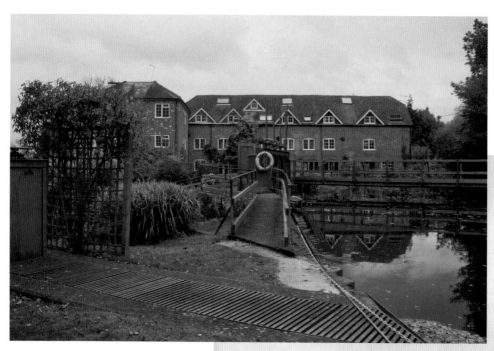

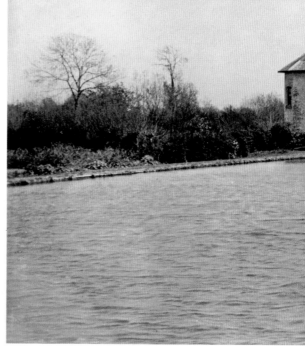

CHAMBERHOUSE MILL, *c.* 1920 (right). The mill was, for centuries, a flour mill powered by water from the River Kennet. There appears to have been a mill on the site since 1390, although the first recorded name of a miller was not until 1656; this was Thomas Eastman. The current mill dates to the nineteenth century. Chamberhouse Manor gets its name from Roger de la Chambre, who was living there in 1250. It is worth noting though that the Chamberhouse estate was part of Crookham Manor until 1445. From the late fourteenth century, local farmers would have brought their corn here to be ground into flour. How popular it was is not known, but the area was certainly not

short of mills. In 1887, the Lord of the Manor, Albert Richard Tull, had new machinery installed including grindstones, shafts and a waterwheel. Between the First and Second World Wars, the mill played host to several events, including church fêtes, swimming and boating. In 1939, the estates of both Chamberhouse and Crookham were sold, the mill having been purchased by John Henry of Colthrop. It continued operating as a mill until 1965, when miller Fred Smith died. It was sold three years later by a Mr Henry. *(J. Salmon Ltd, Sevenoaks, Kent)*

TODAY, THERE IS evidence of change, but the building retains much of its historical character. By the end of 1977, the mill had been converted into residential properties. Some of the other properties on the site were also converted; some, such as the millers' house, were demolished and rebuilt – into three houses in the case of the millers' house.

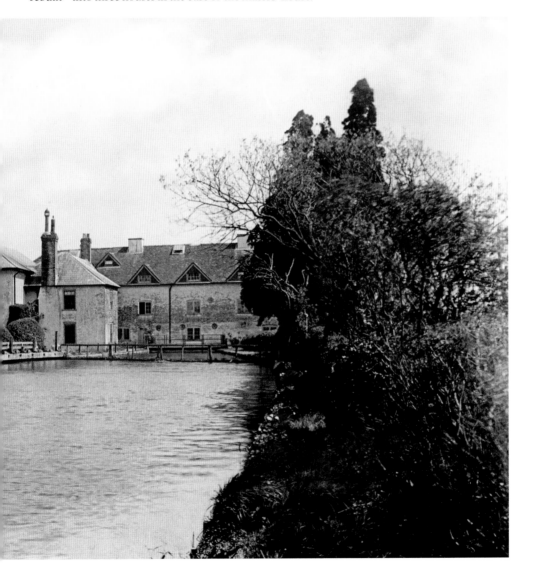

CROOKHAM HOUSE

CROOKHAM HOUSE, THE residence of the Tull family, *c.* 1905 (below). Thatcham, at the time of the Domesday Book, was a royal estate consisting of five manors: Thatcham, Midgham, Greenham, Crookham and Colthrop – some remain in part of the Thatcham boundary today. Archaeological finds – Belgic pottery for example – show that the area surrounding Crookham House has seen visitors as far back as the first century AD. The Crookham estate was bought in 1729 by Bulstrode Peachey, who built the first Crookham House on the site of the present Crookham House, or at least near to it. The house, but not the estate, was later sold, in 1790, to Richard Tull. The house consisted of about 117 acres, a garden and parkland, two entrance lodges and a house for the gardener. The estate land was in excess of 2,000 acres. In 1850, Richard Tull, a descendent of the previously mentioned Richard, demolished the house and rebuilt it; the reason for this is unknown. The Tull family became active within the local community and financed many projects. In 1867, Richard and Henry Tull paid for the building of the Crookham

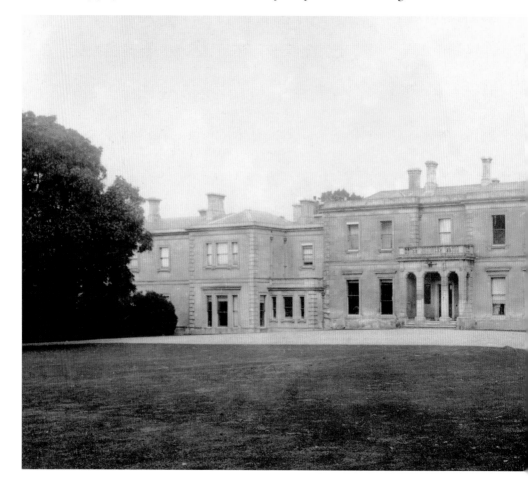

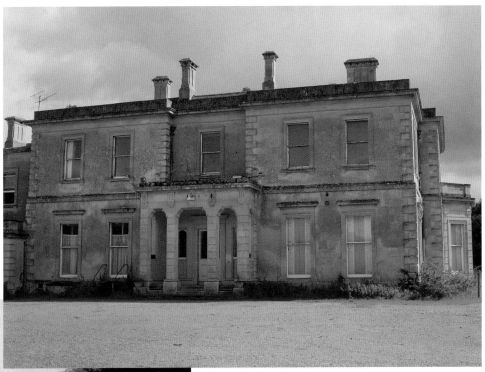

Church of England School, St Barnabus' School. Later, in 1876, Albert Tull payed for the rebuilding of the National School in the Broadway. In 1875, Albert Tull bought the Crookham estate and became Lord of the Manor of Chamberhouse and Crookham. In 1939, the house and estate were put up for auction, which included over 2,000 acres of land, six farms, 300 acres of woodland and more. The house was purchased by the Great Western Railway and used for offices during the Second World War. *(Reproduced with permission from the Museum of English Rural Life, University of Reading)*

IN 2008, THE exterior of the house looks much the same; the interior though has been altered beyond recognition. The house changed hands several more times until 1961, when it was opened as a school called Crookham Court. The school survived until 1989 and, shortly afterwards, the house was converted into flats. In 2011, the house was again put up for sale and at the time of writing (2012) the future of the old building is uncertain. *(Photograph by Peter Allen, 2008)*

COLTHROP COTTAGES

COLTHROP COTTAGES LOOKING east, *c.* 1906 (right). The canal is on the left, just out of view. There are several houses around Thatcham that once belonged to Colthrop Mill; for example the Twelve Apostles on the Bath Road. However, it is the cottages at the southern end of Colthrop Lane that are typically referred to as Colthrop Cottages. The cottages were considered by many of their early residents, who all worked at Colthrop Mill, to be a small village. One cottage, No. 12, was occupied by George and Alice Muttram, after they moved in 1911 from Plymouth. George worked as a maintenance fitter at the mill and together the couple had ten children, which saw them move from No. 12 to 18. After the First World War, George became an auxiliary fireman for the mill. The cottages were served by various tradesmen including Wyatt's the butcher, Jeffries' bakery and Pinnock's coal merchants. One tradesman, Harry Picket, also lived locally in No. 2. Harry, with his three cows,

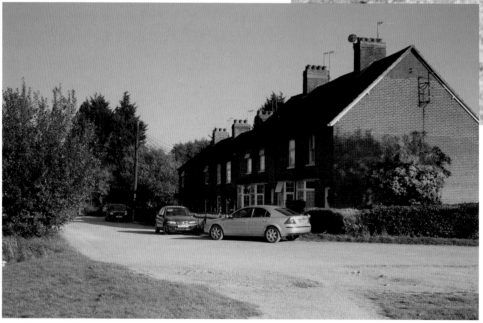

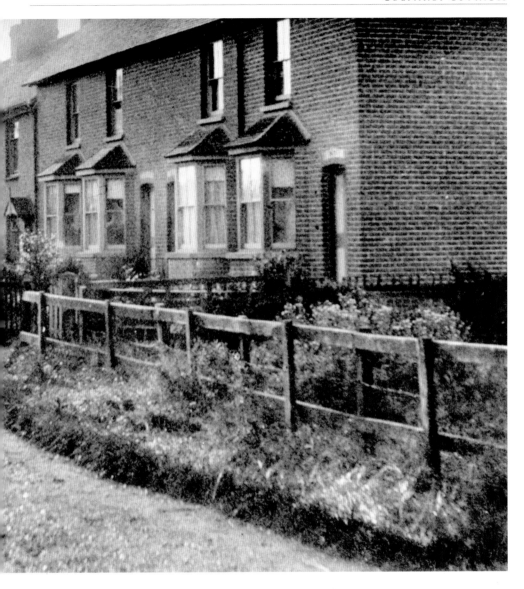

supplied milk to the cottages. Adjoining this property was the Reading Room, which was also used as a Sunday school run by Miss Evelyn Henry, daughter of John Henry, owner of the mill. Mr and Mrs Nightingale, who lived at No. 20, established a local shop which was used by residents until the 1950s, when the mill opened its canteen.

MANY OF COLTHROP Cottages have now been demolished. Some have survived, though, and are hidden amongst the trees and undergrowth in a derelict state. The surviving properties are still accessed by Colthrop Lane, as they have been for centuries. Today, this means passing through a rather large industrial estate. Behind the cottages is Kennetholme Quarry, where gravel extraction is currently taking place, conducted by the firm Grundon Sand & Gravel.

THE CANAL AT COLTHROP

COLTHROP SWING BRIDGE, canal and mill in 1976 (right). On the left are Colthrop Cottages and on the right, part of Colthrop Mill. The first record of a mill at Colthrop dates to the fifteenth century, when the mill and estate were held by Winchester College. Records identify it as a corn mill. Later, in the same century, it was rebuilt into two mills. One of the millers at the end of the century was Thomas Yonge. By 1540, it was described as a cloth mill and around 1560 a Newbury clothier, Thomas Dolman, purchased it. The Dolmans occupied it until the eighteenth century, when Brigadier General Richard Waring purchased the estate. At this time the mill was separated from the manor, allowing either to be sold separately. Around 1740, William Ball Waring had converted it to a paper mill. John Henry purchased the mill in 1864, at which time it produced 8 tonnes of paper per week and employed twenty-five people. By the time he died in 1905, it was producing 100 tonnes of paper each week and employed 200 people. The bridge, which is known to have been in place before 1877, is today fixed and has been raised to allow canal traffic to pass easily underneath. In 1918, Cropper and Co. Ltd took an interest in the mill and formed Colthrop Board and Paper Mills Ltd. With the Henry family still in charge, improvements were made with new machinery and buildings. The South Board Mill was built around 1921 to accommodate the machinery of Containers Ltd, which produced cardboard.

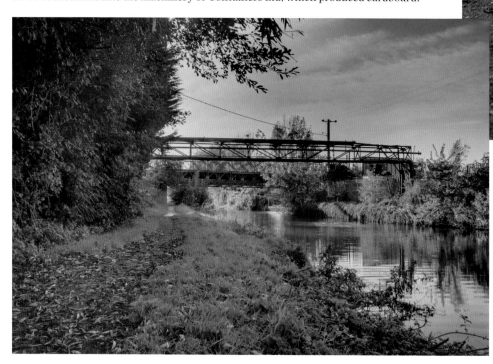

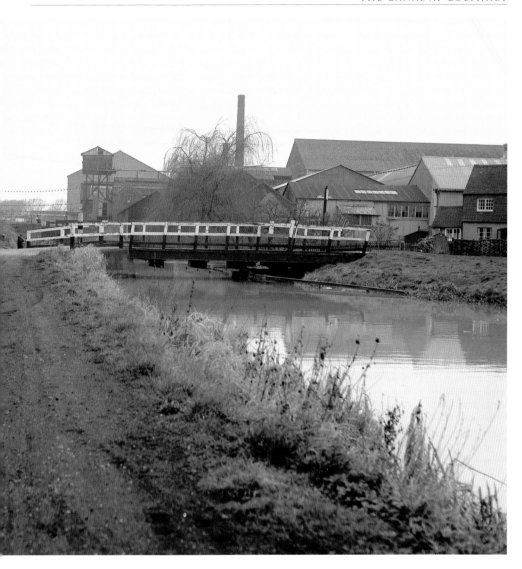

Reed Paper Group Ltd took over the whole of the Colthrop site in 1956 and shortly after built the North Board Mill. Colthrop Mill was employing over 900 people by 1981 and producing over 110,000 tonnes of board a year. By 1985 things had changed; the South Mill was closed and the North Mill followed suit in 2000, effectively ending the history of paper manufacturing at this site. *(Photograph by Dr Neil Clifton)*

ALTHOUGH THE MILL itself is now closed, evidence of its working days is still visible. Some of the buildings survive and others have been demolished and rebuilt for use by a variety of other businesses, including Thatcham Motor Insurance Repair Research Centre, British Gas Academy and Prestige Network Ltd. They cover the area from the Bath Road right back to Colthrop Cottages, where Grundon Sand & Gravel is located.

If you enjoyed reading this, then you may also like

Reading Then & Now
STUART HYLTON

Reading was one of the first towns in the world to be photographed: William Henry Fox-Talbot, the inventor of modern photography, set up his workshop here and the streets of the 1840s town became the test-bed for the new technology. This book takes a wide range of historic views of Reading and recreates their modern counterparts in colour. Rapid economic growth has seen dramatic change in the town, and this fascinating book documents the transformation, as well as the continuity that has survived it all.

978 0 7524 6325 4

Haunted Berkshire
ROGER LONG

For such a small county, reports of supernatural happenings around Berkshire are surprisingly plentiful, from shades of kings, queens and dukes to apparitions of sobbing maidens and moaning men. They haunt all manner of places such as castles, mansions, churchyards, cottages, follies and grottoes, and come under different guises; sometimes victims such as wretched murdered children, other times criminals like thieving highwaymen.

978 0 7524 5907 3

Berkshire Murders
JOHN VAN DER KISTE

Berkshire Murders is an examination of some of the county's most notorious and shocking cases. They include young Hannah Gould, whose throat was cut by her father in a frenzied attack at Windsor in 1861; Nell Woodridge, murdered by her husband in 1896 and later immortalised in Oscar Wilde's 'The Ballad of Reading Gaol'; and Minnie Freeman Lee, whose body was discovered in a trunk in 1948. John Van der Kiste's enthralling text will appeal to all those interested in the darker side of Berkshire's history.

978 0 7509 5129 6

Bath in the Blitz: Then & Now
DAN BROWN & DR CATHRYN SPENCE

In April 1942, Bath suffered enormous devastation at the hands of the Luftwaffe. More than 19,000 buildings were destroyed or damaged, and over 400 people were killed. Yet contemporary Bath bears almost no sign of this history – it appears to be an elegant and intact Georgian city. This book is a memorial to the city's sufferings and the bravery of its residents during the Second World War. With stunning archive images and modern photographs, it seeks to reveal the truth after half a century of silence.

978 0 7524 6639 2